SKYWRITING
journal

by Byron Jorjorian

QUIRK BOOKS
PHILADELPHIA

BYRON JORJORIAN is a nature photographer based in Tennessee.

Library of Congress Cataloging in Publication Number: 2010927127

ISBN: 978-1-59474-491-4

Printed in China

Designed by Jenny Kraemer
Production management by John J. McGurk
Photography by Byron Jorjorian
Please visit ByronJorjorian.com

10 9 8 7 6 5 4 3

Quirk Books
215 Church Street
Philadelphia, PA 19106
quirkbooks.com

Birthday Thank-Yous (& Graduation)

- Nana & Papa: $$$
- Mary: $ & bags
- Venus: $
- Aunt Lisa: $ (& more $)
- Mom & Dad: $, Giants Jersey
- Lauren: apple lotion & sunglasses
- Klaryssa: Cream GC, tattoos, bandeau, earrings
- Aunt Julie: $
- Jake: AMC GC
- Nicole: Ulta GC, essie set, booklet
- Camille: Sbux GC
- Emmanuelle: iTunes GC
- Nathan: iTunes GC
- Auntie Susie: $
- Auntie Cola: $
- Richmonds: $
- Sylvia: $
- Auntie Itza: $ in GC (Maggiano's, Visa, Sbux)
- Uncle Sam: $ & Dancer Pin
- Auntie Annie: chocolate, $
- Aunt Frances: $, cards, booklet

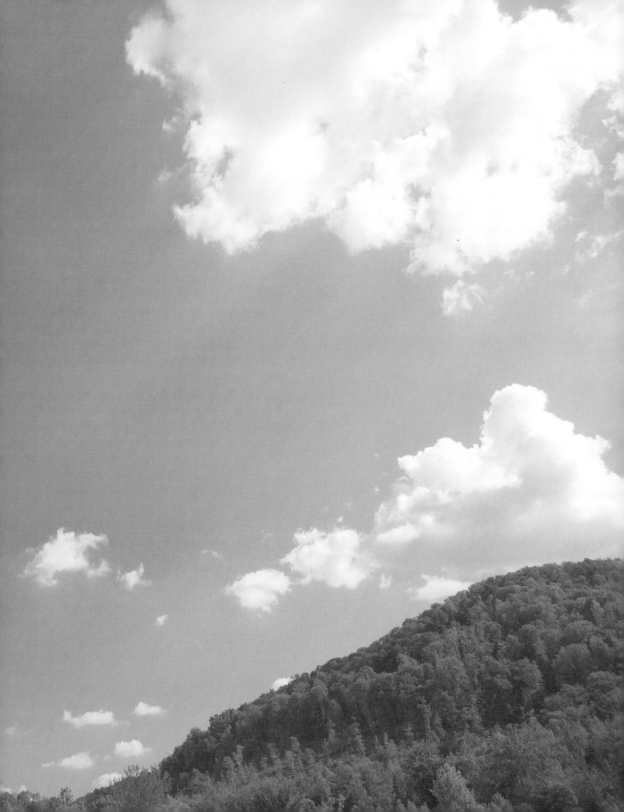

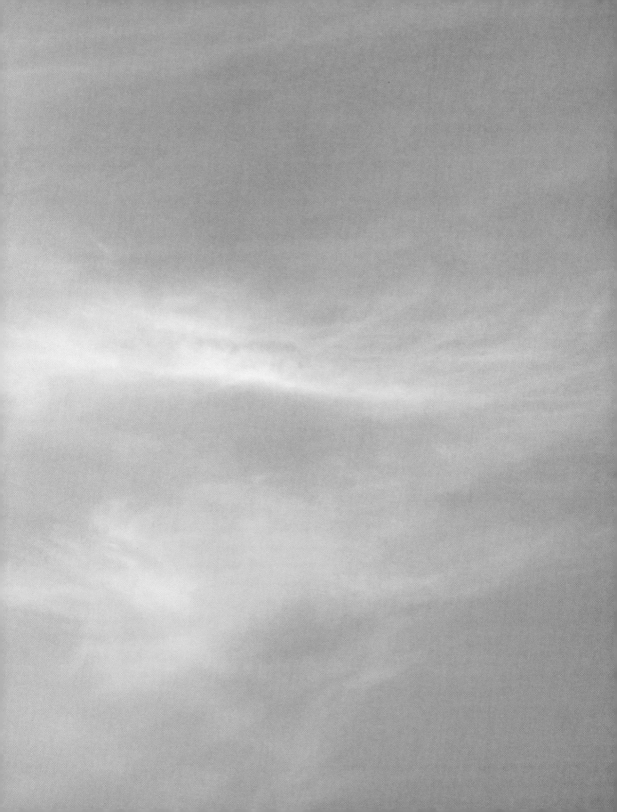

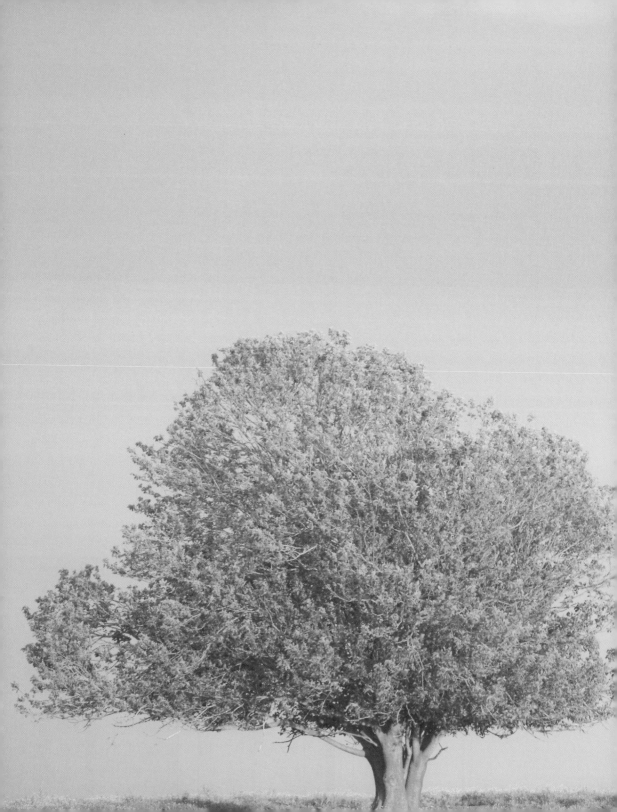

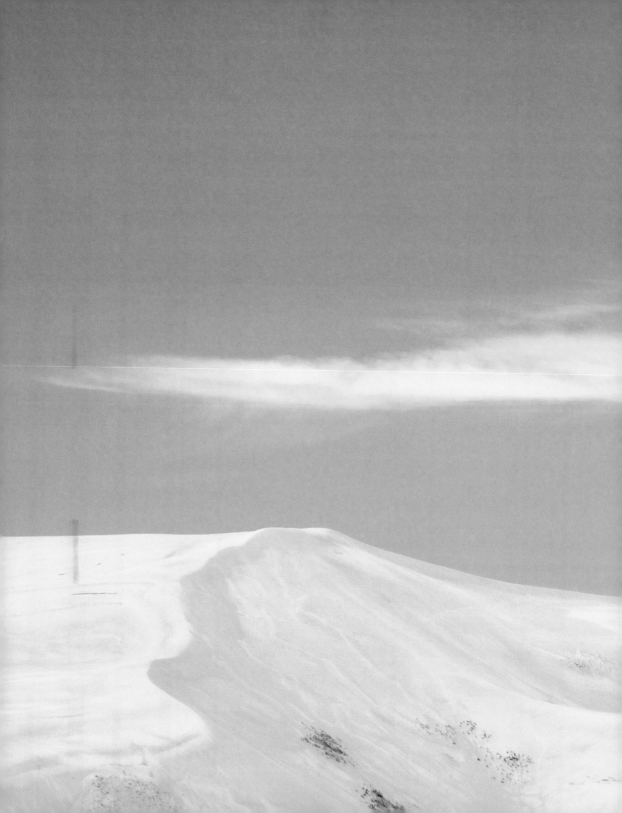

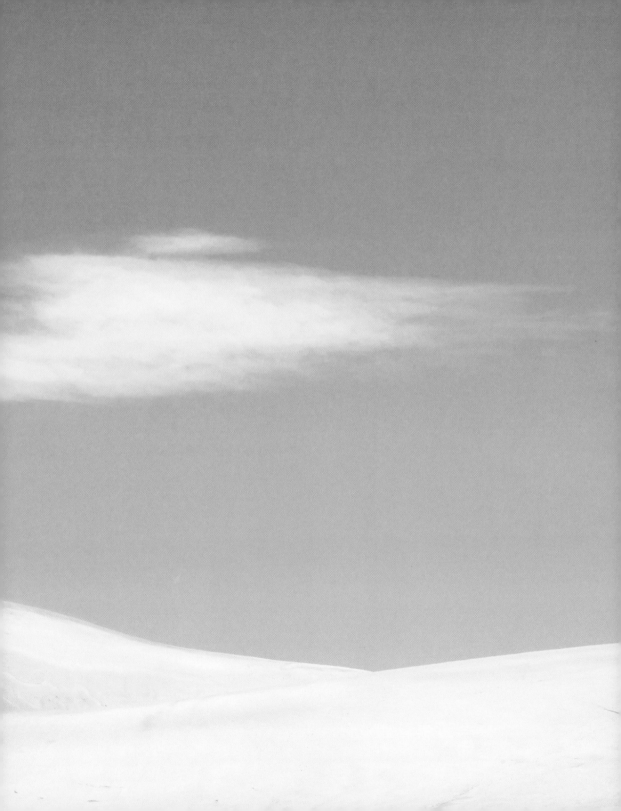

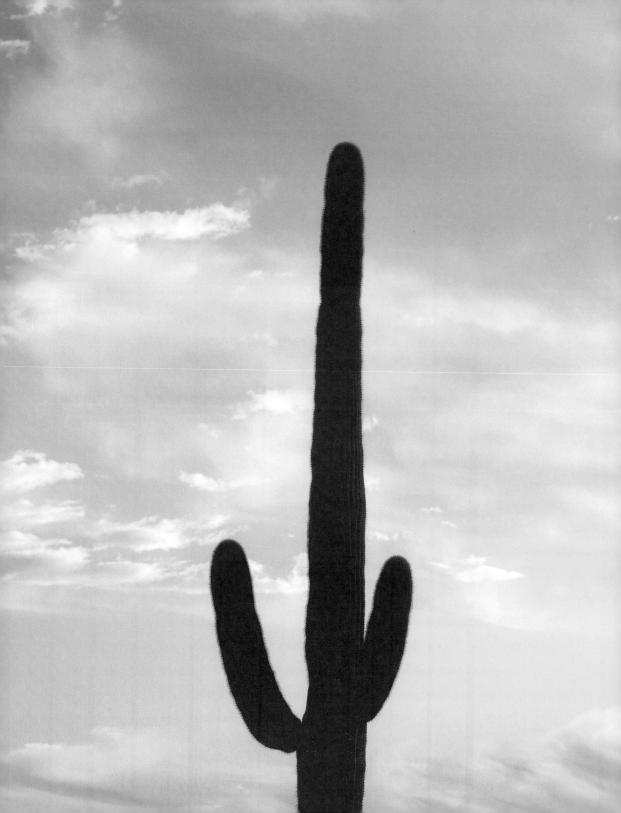

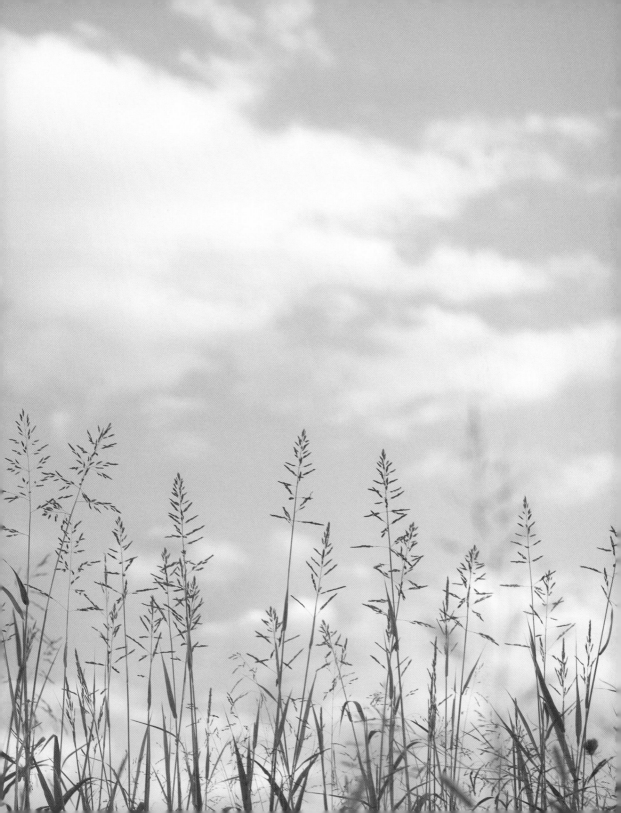

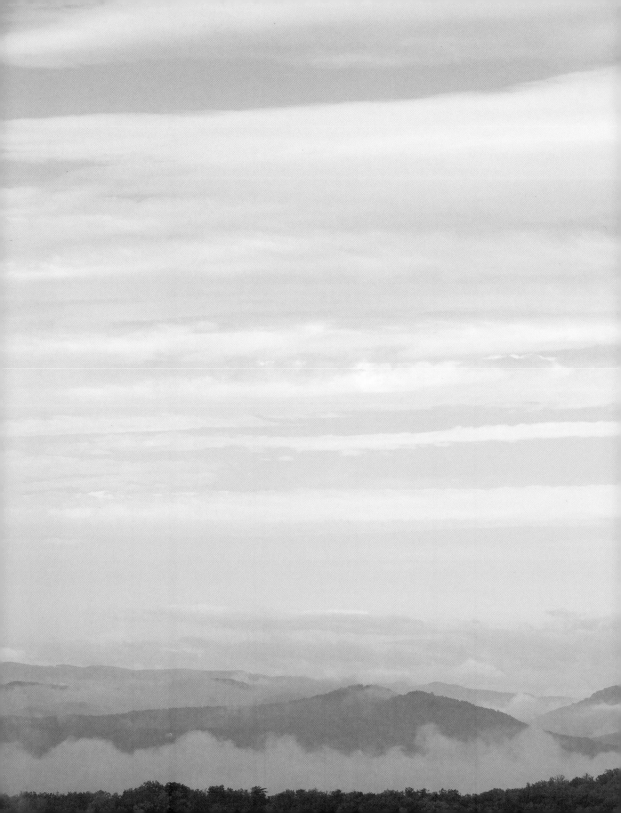

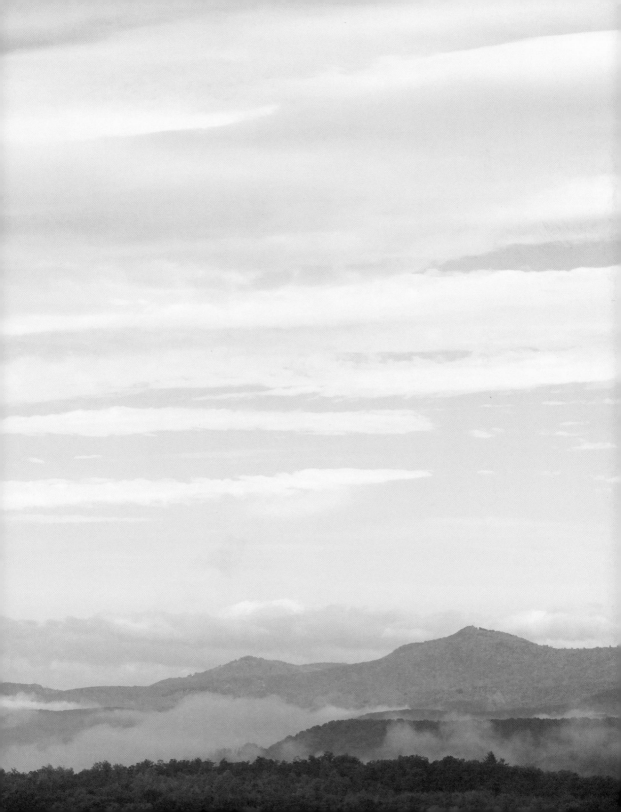

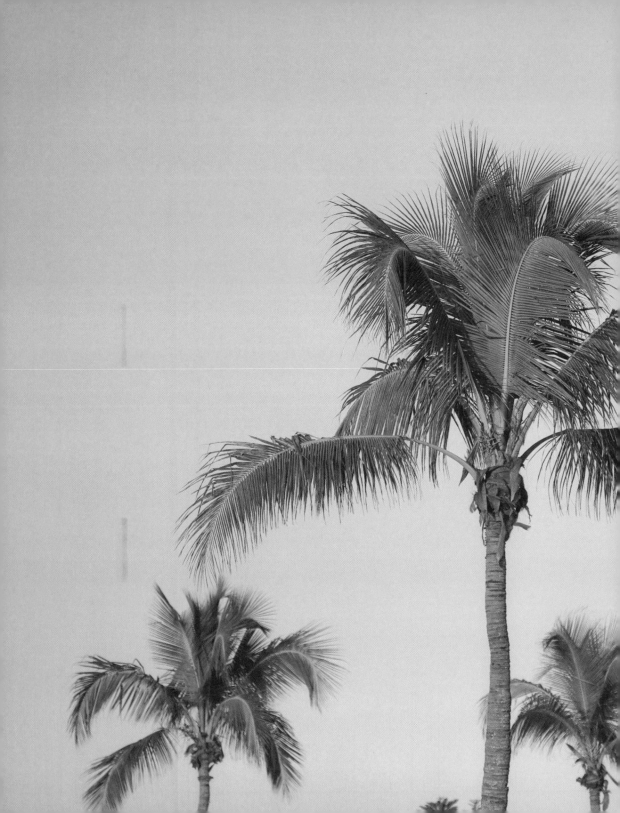

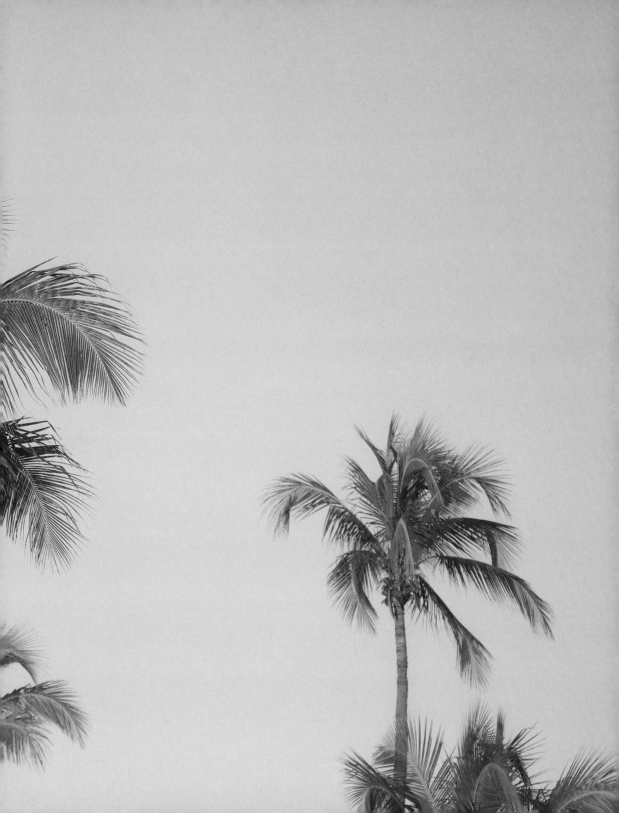

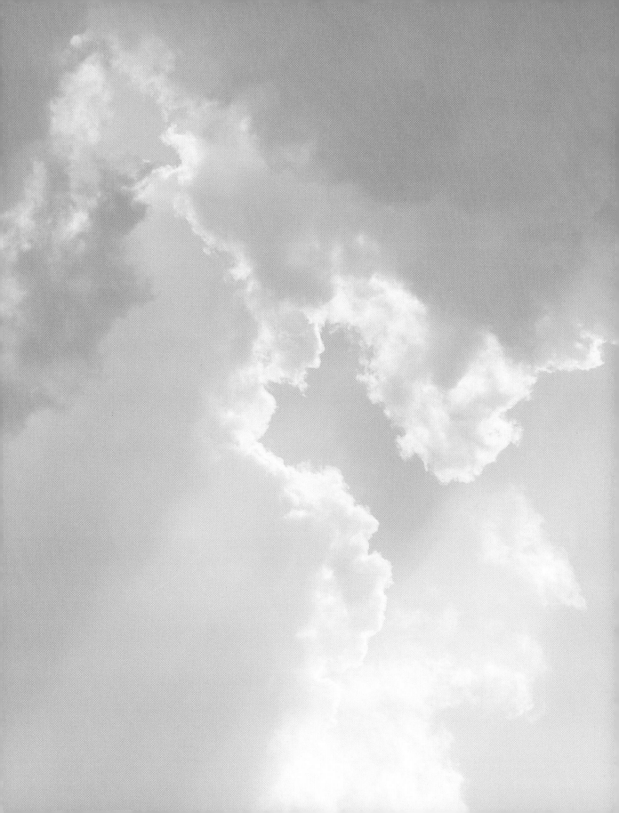

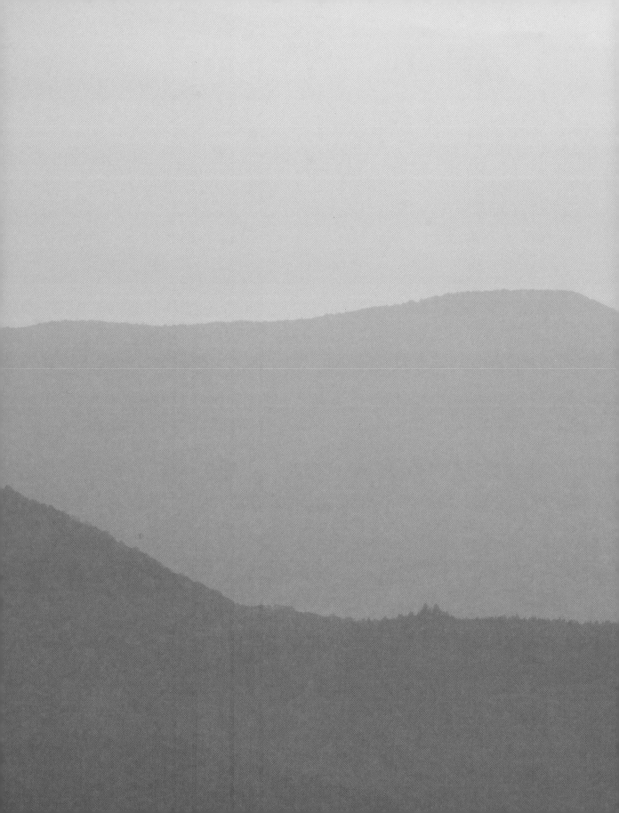

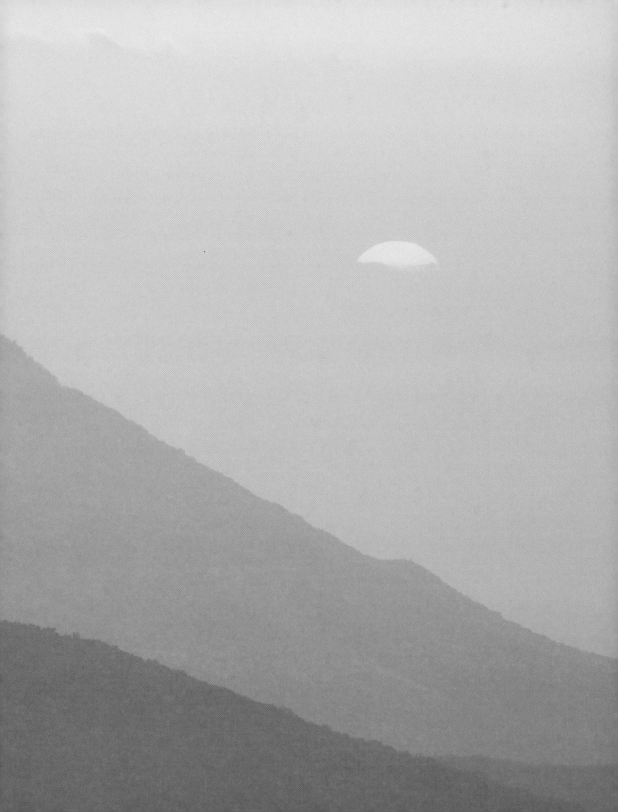

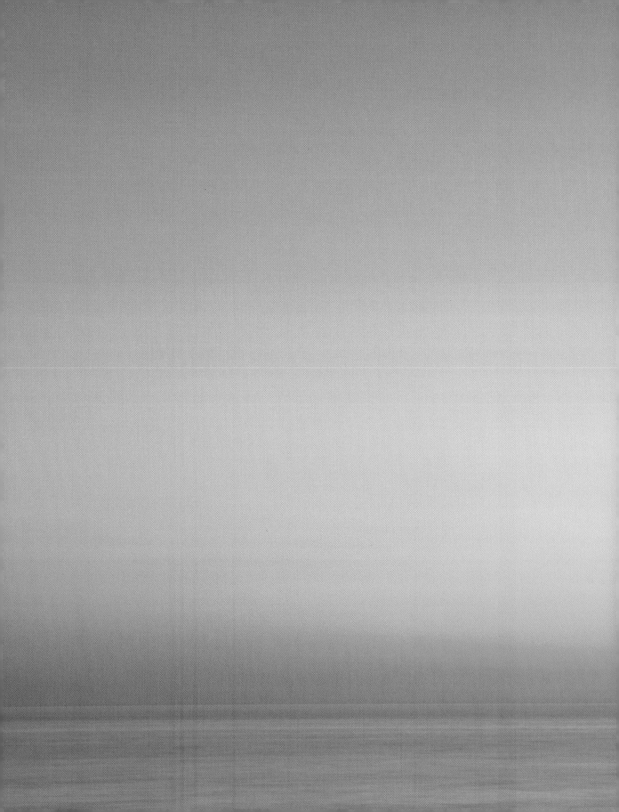

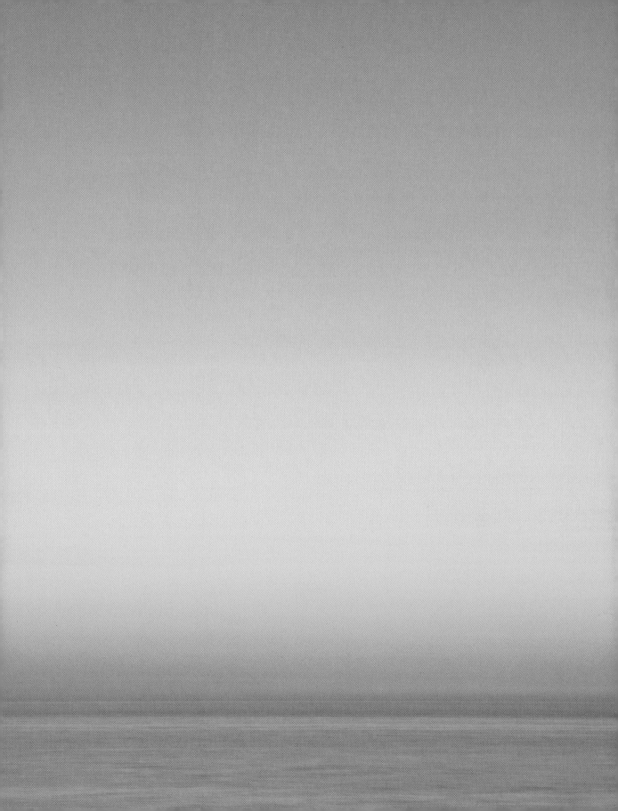

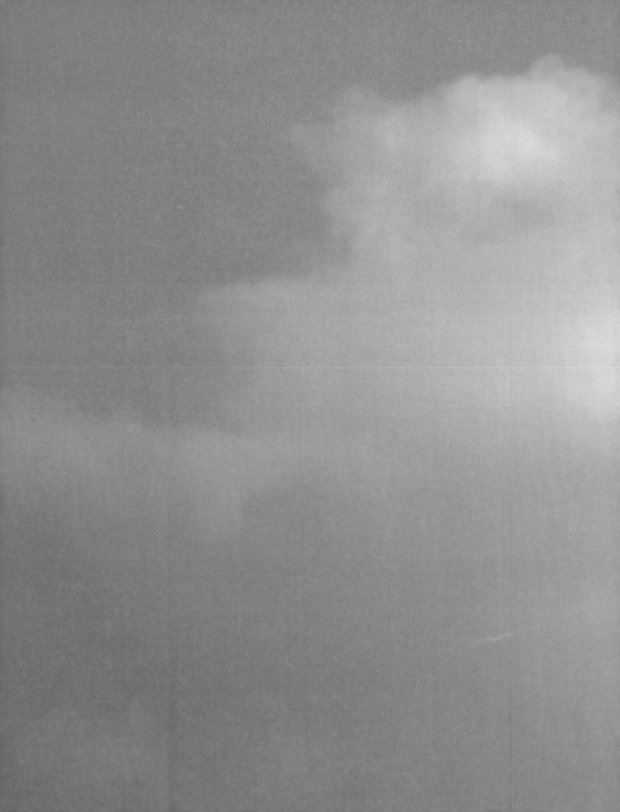

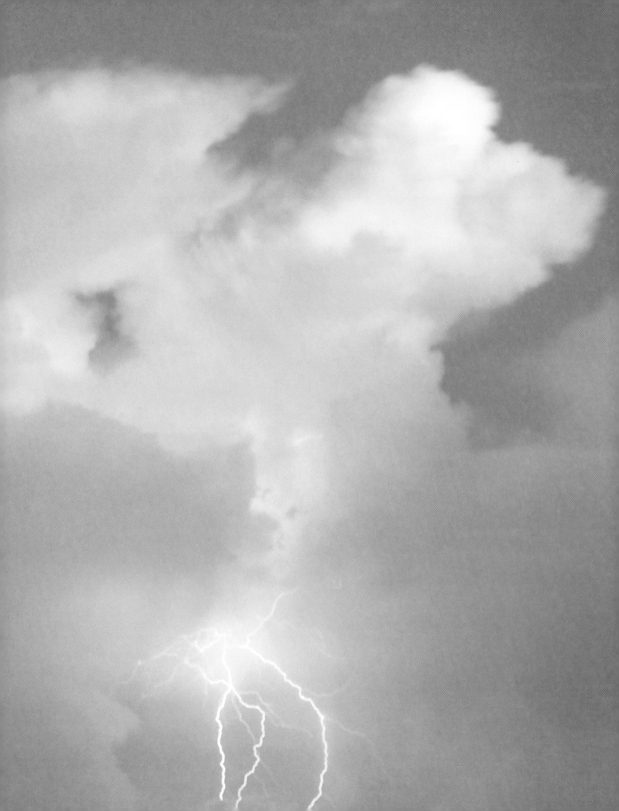

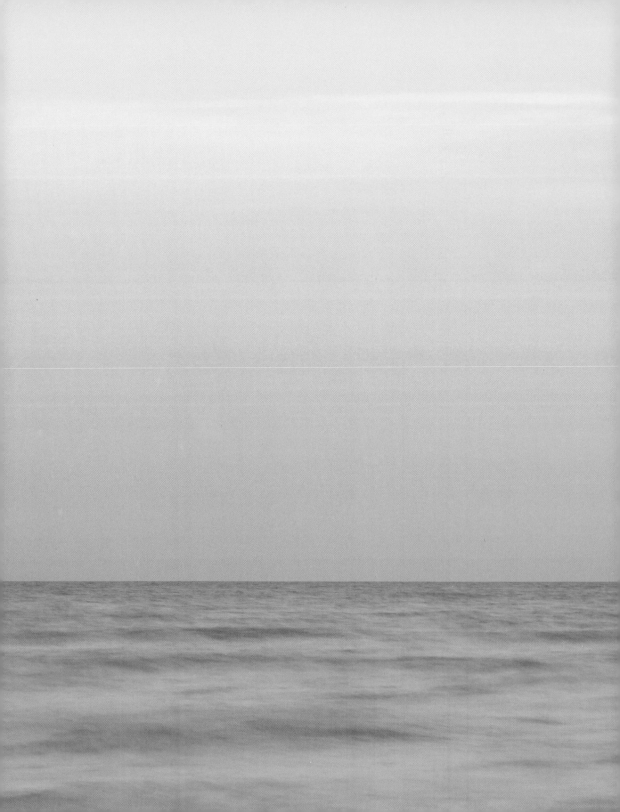

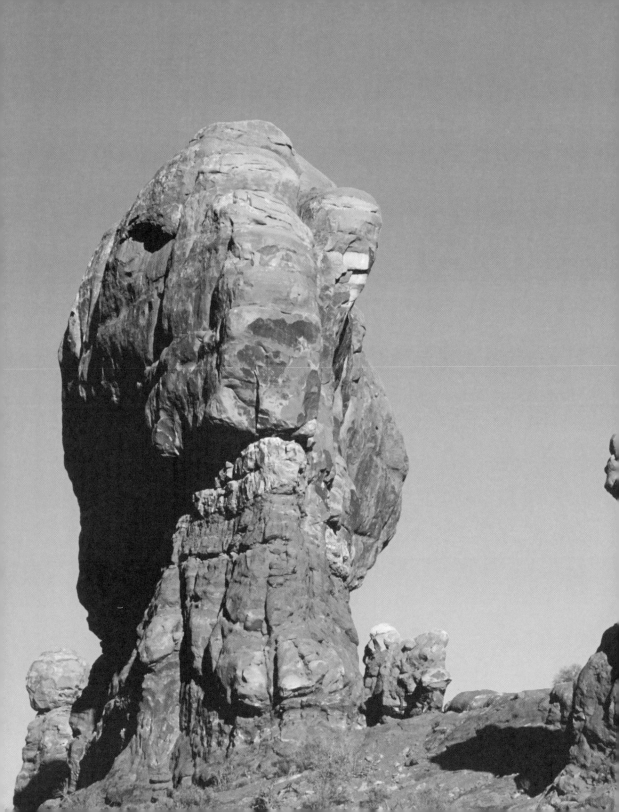

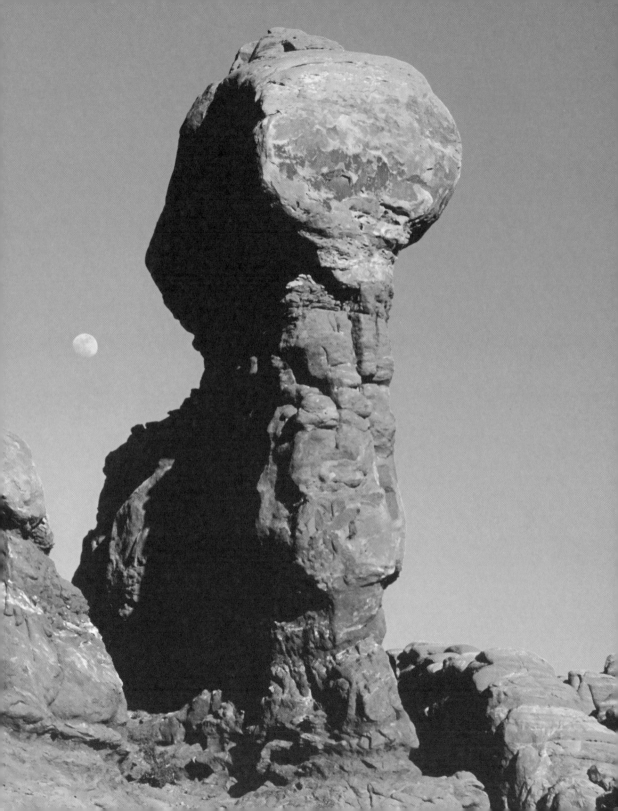

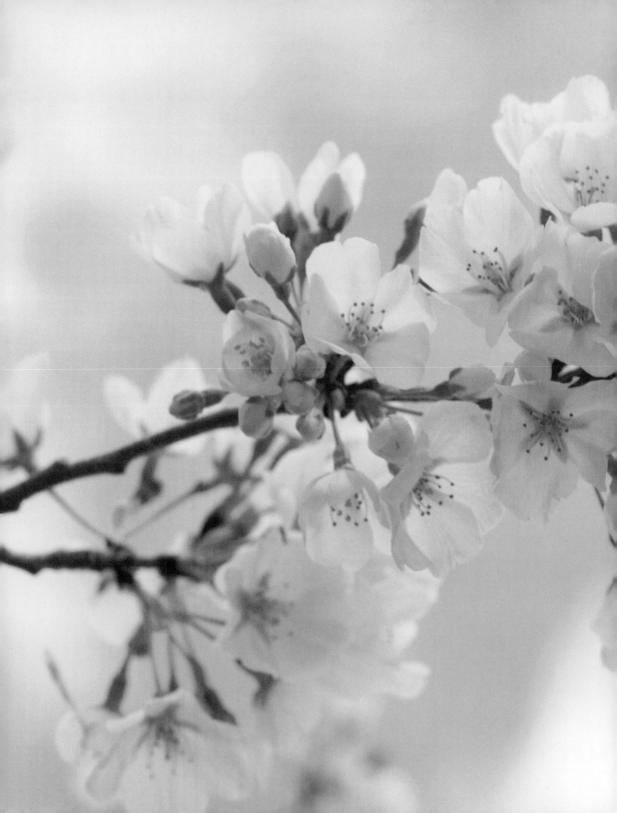

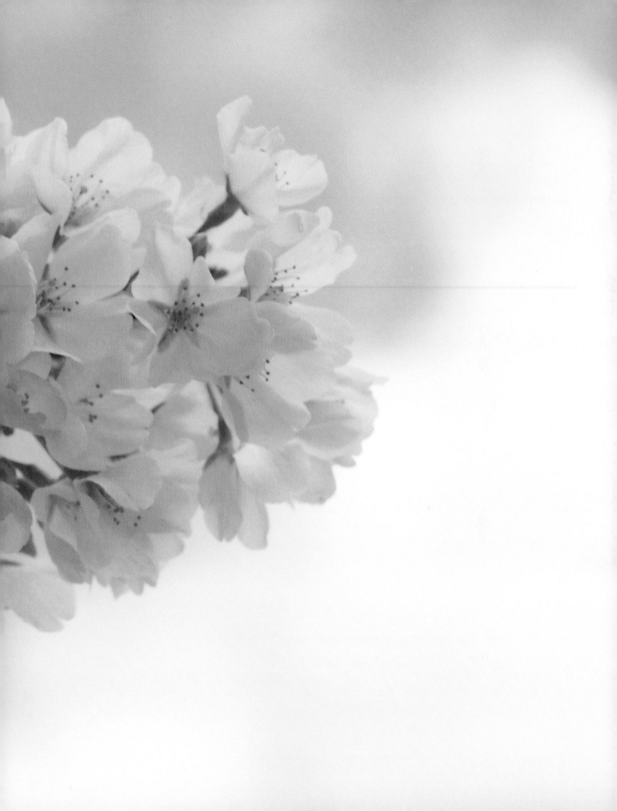

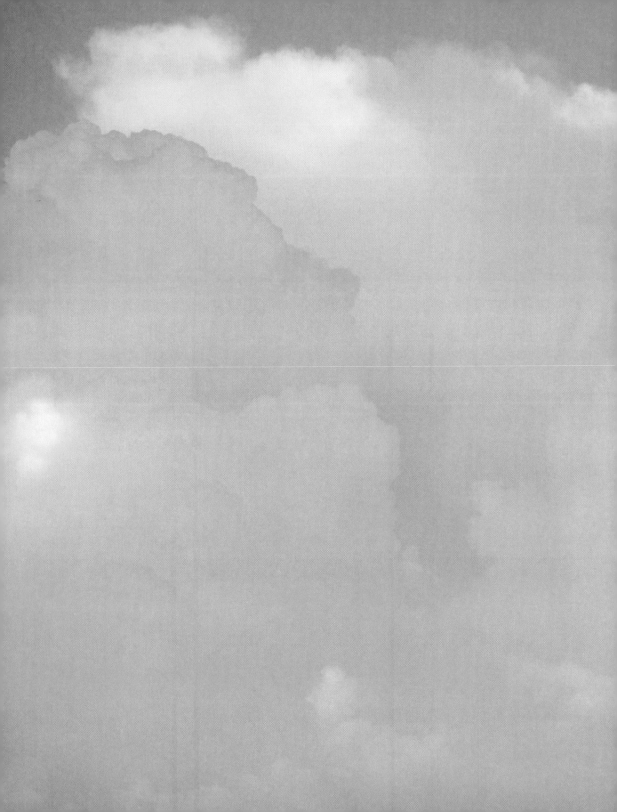

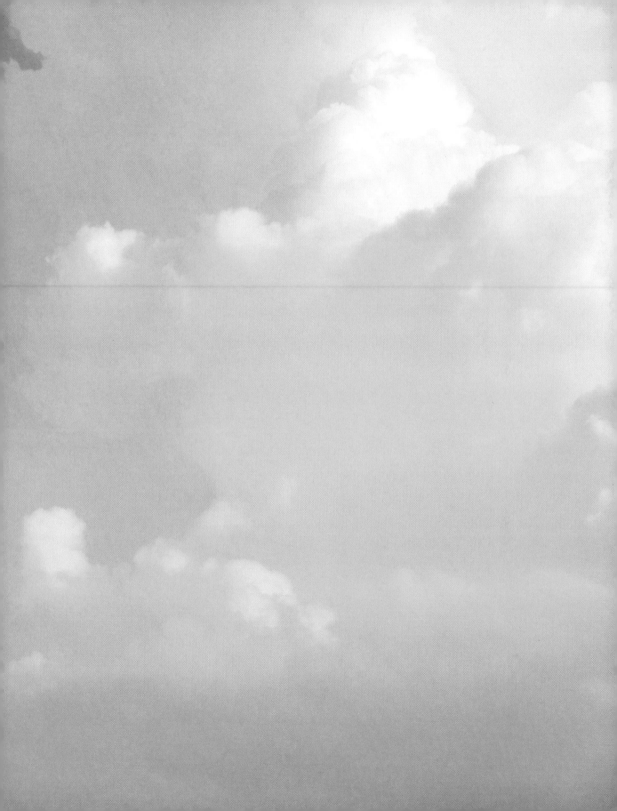

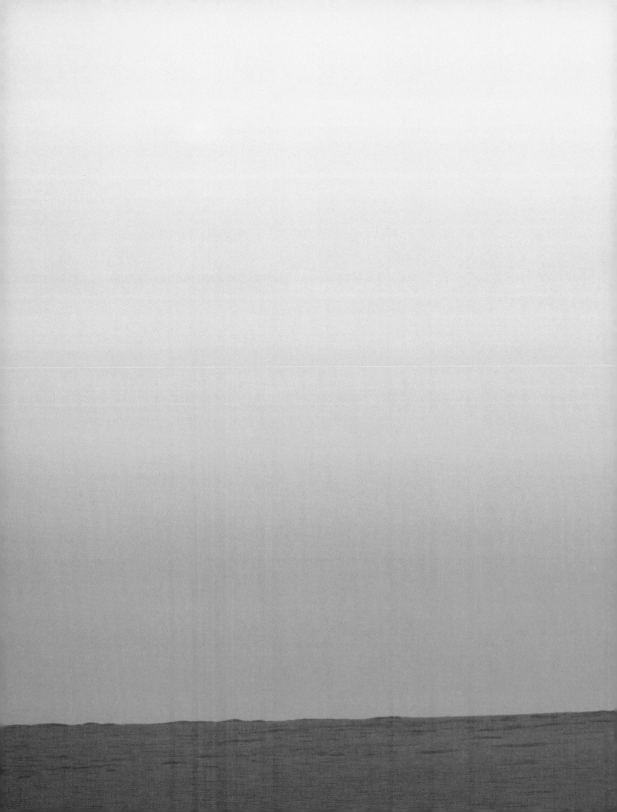

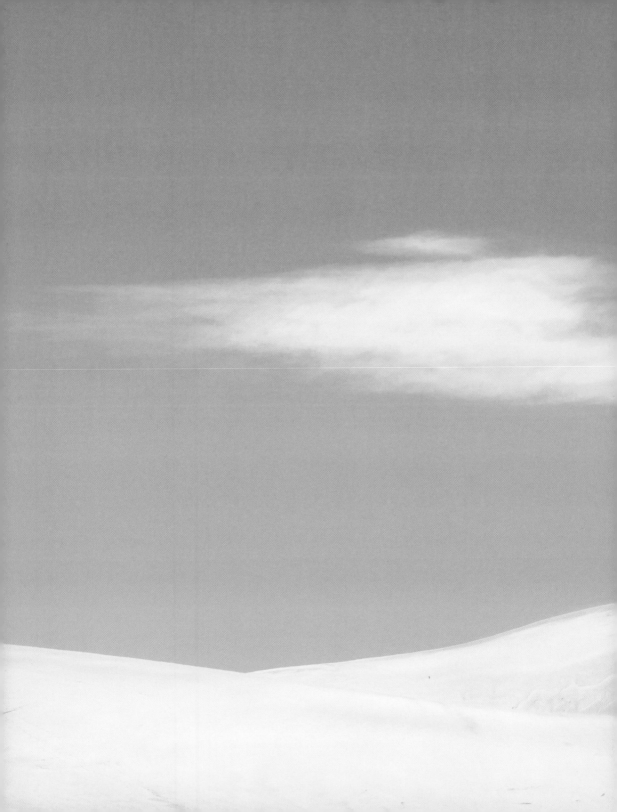

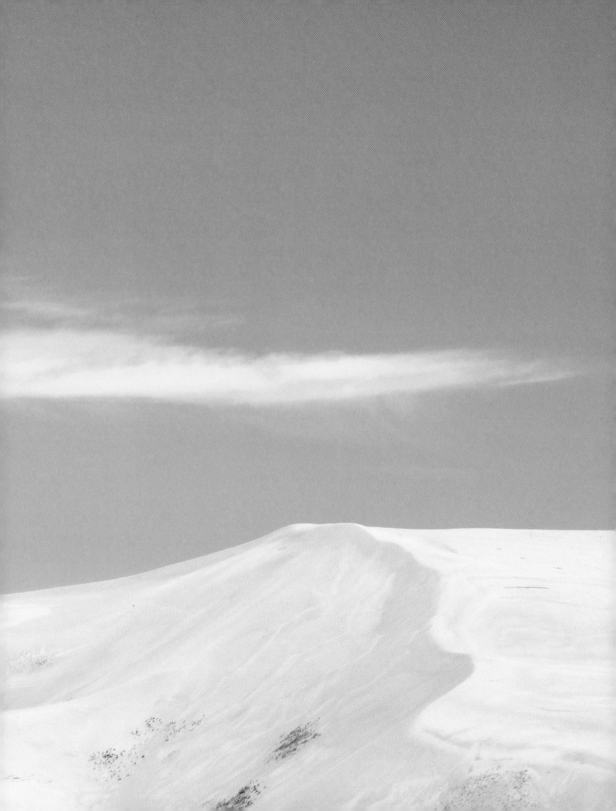

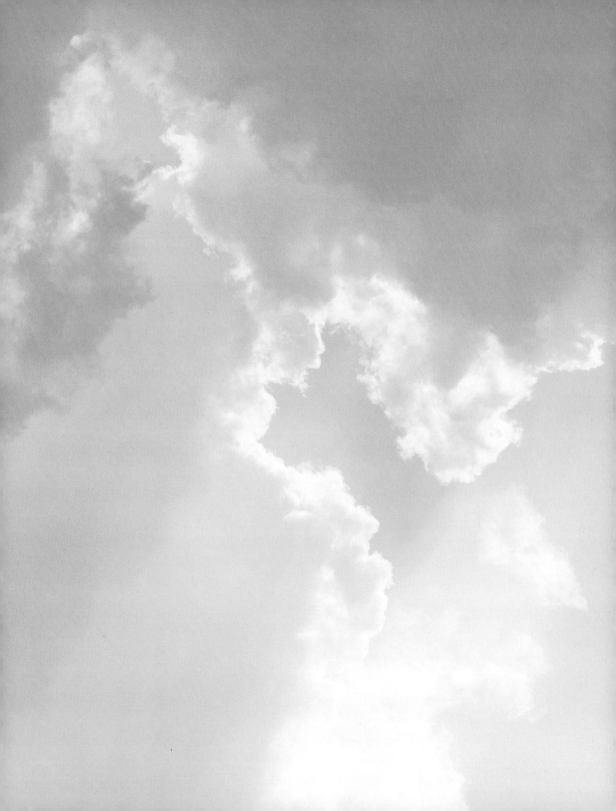

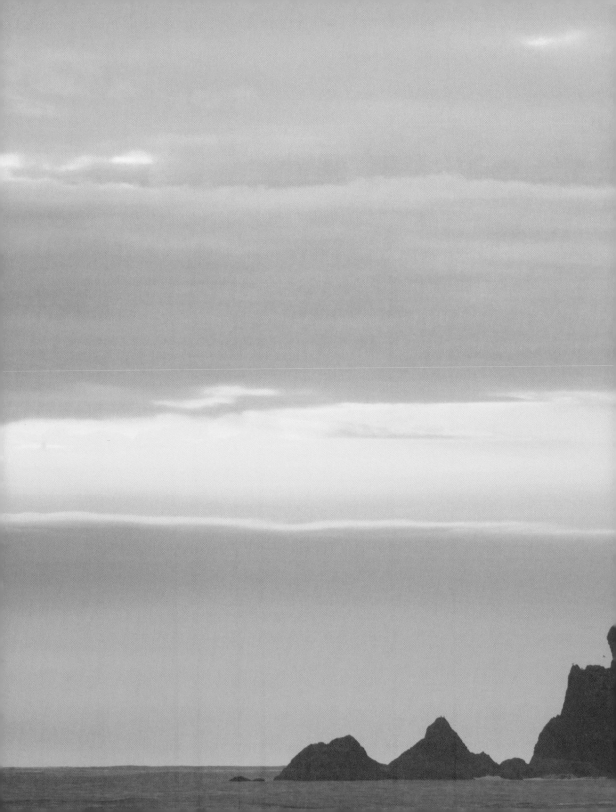

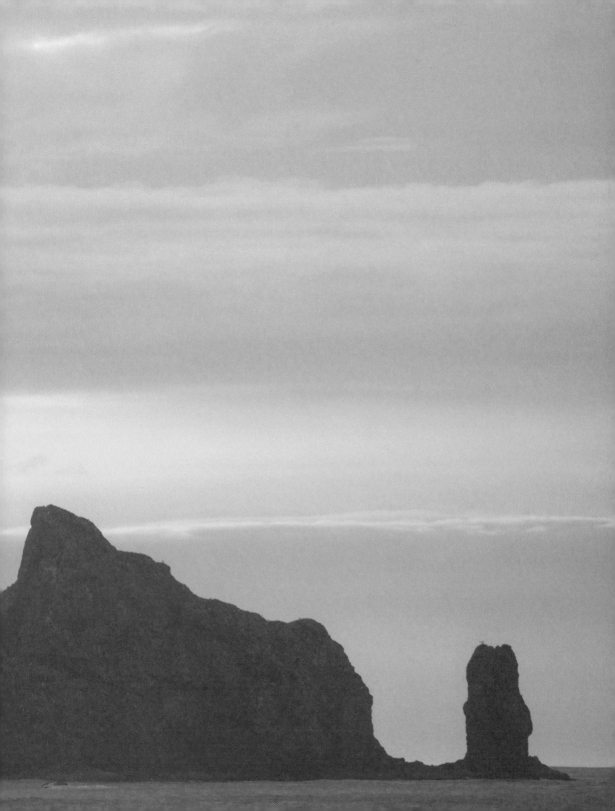

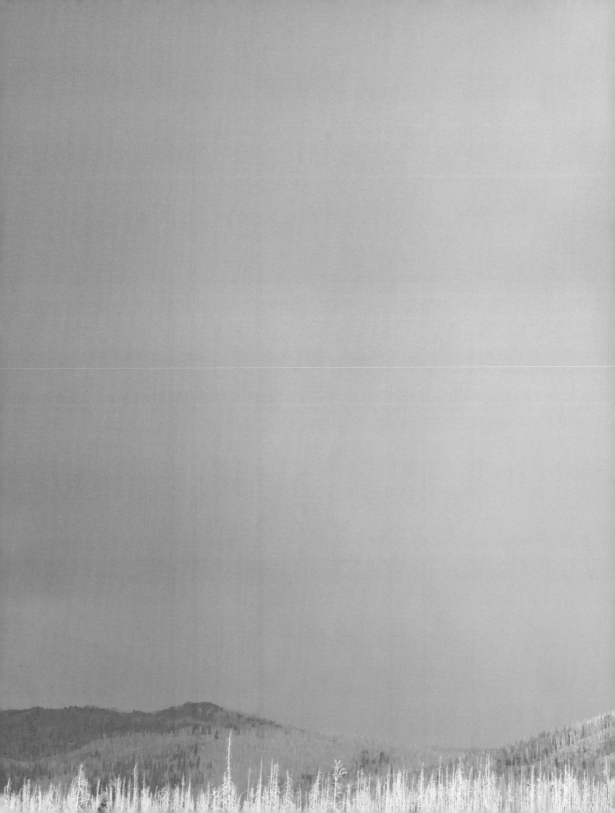

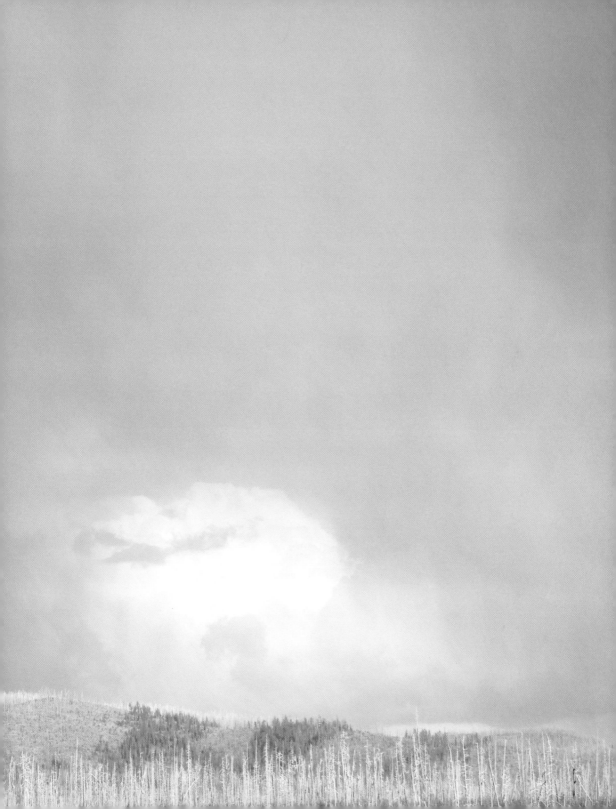

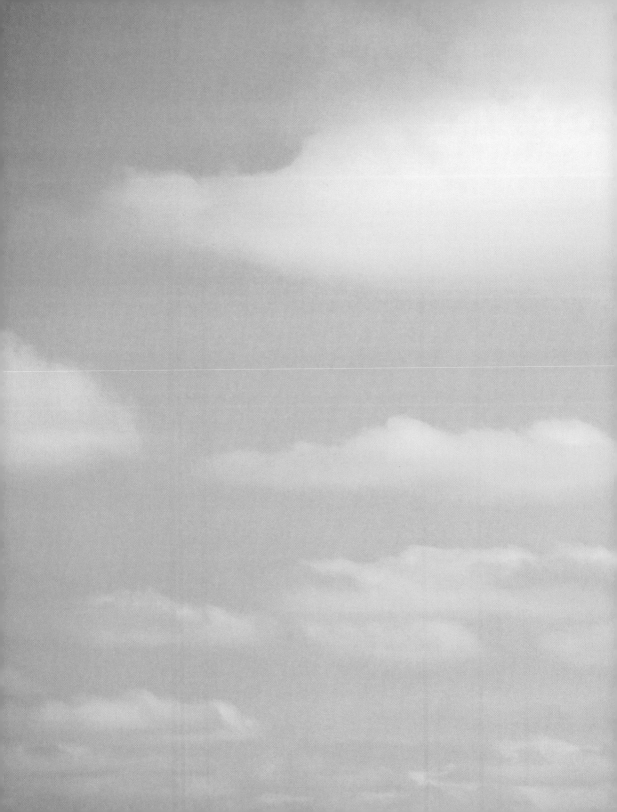

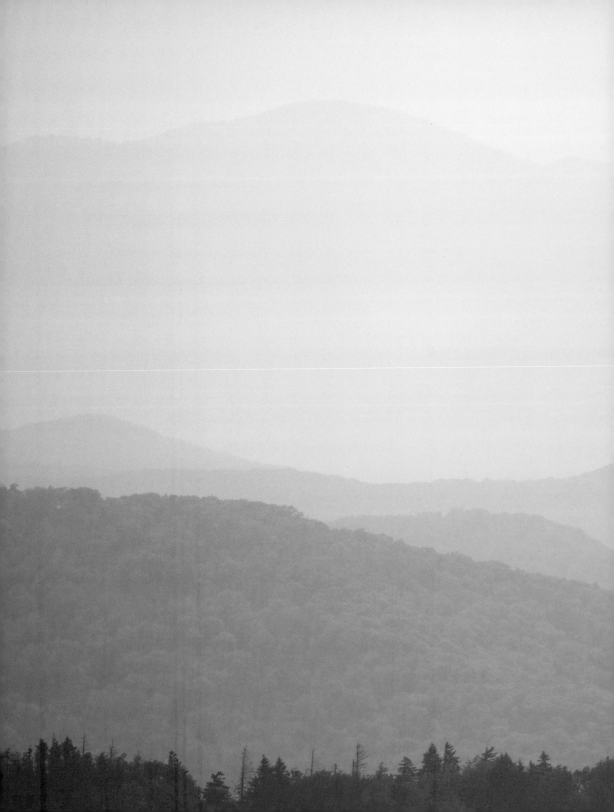

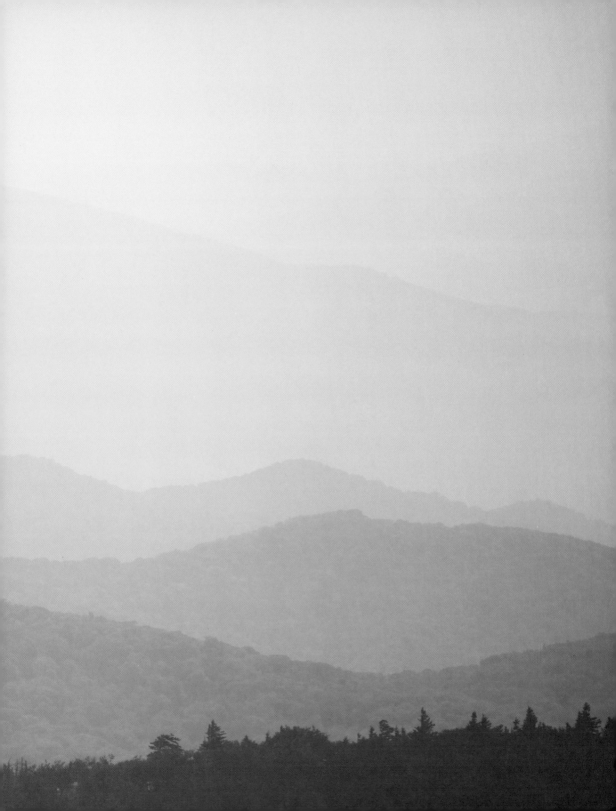

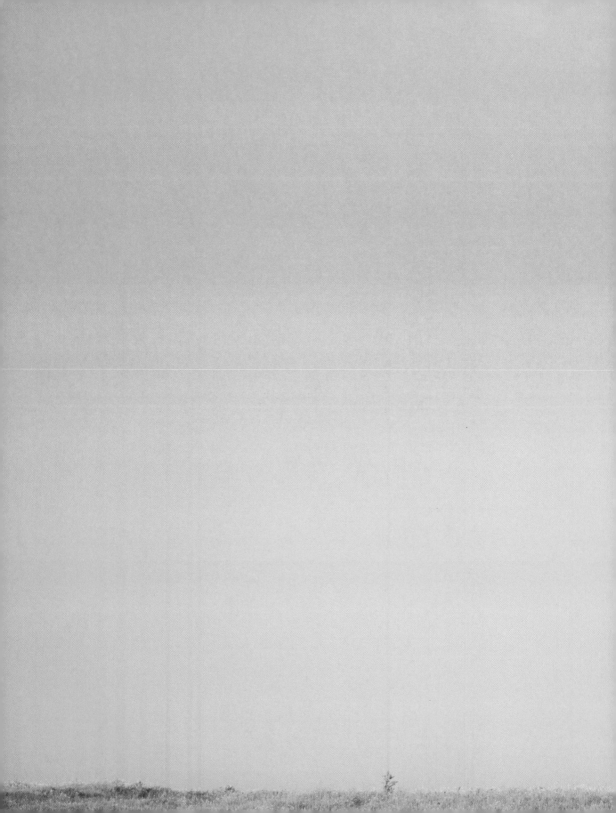

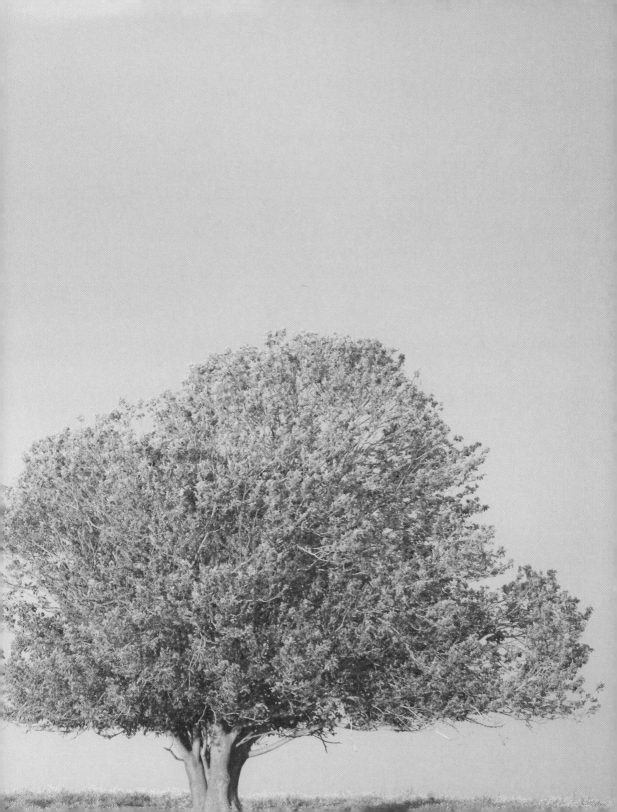

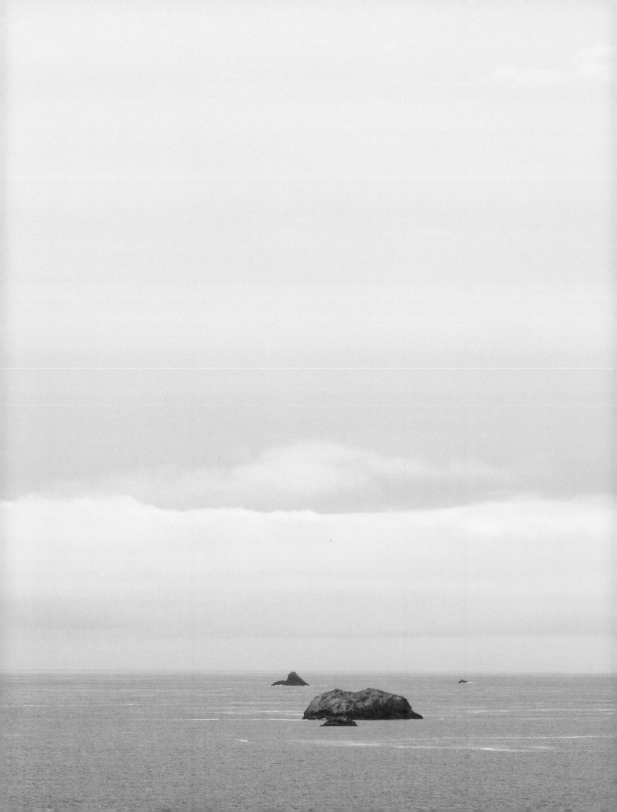

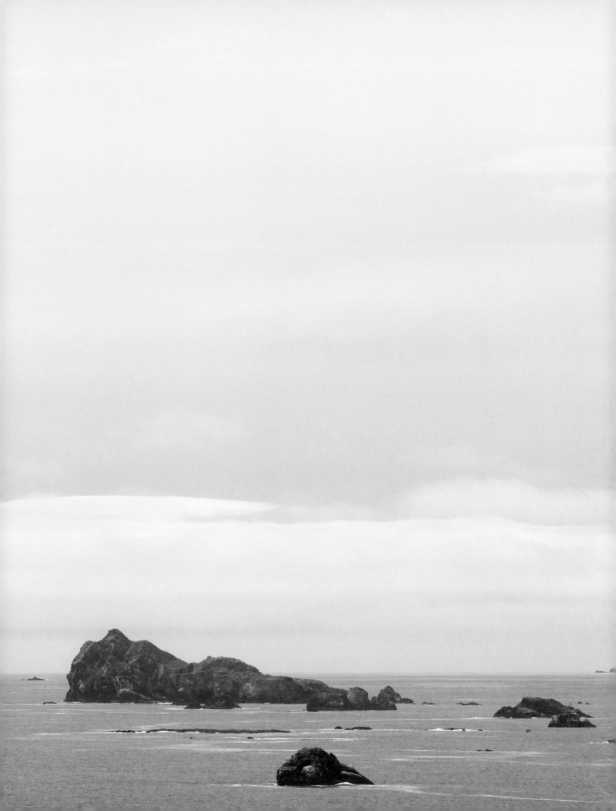

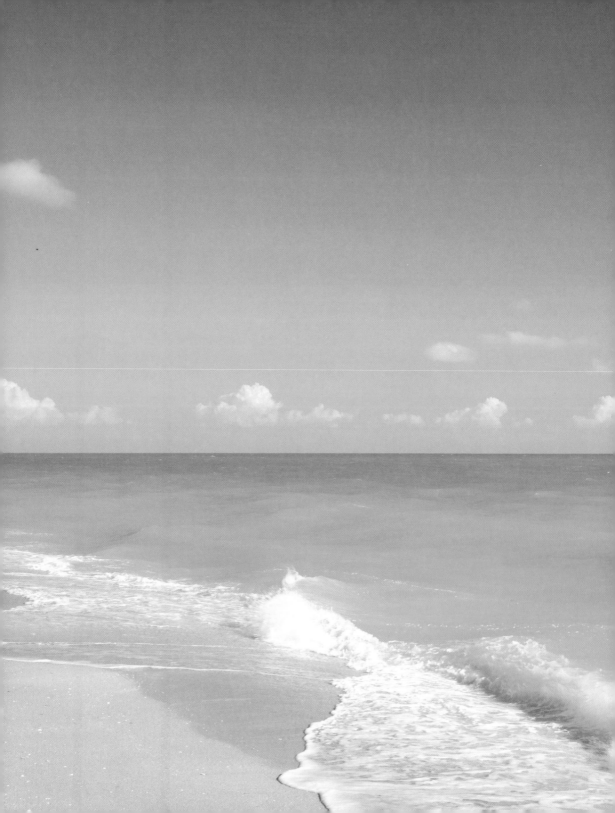

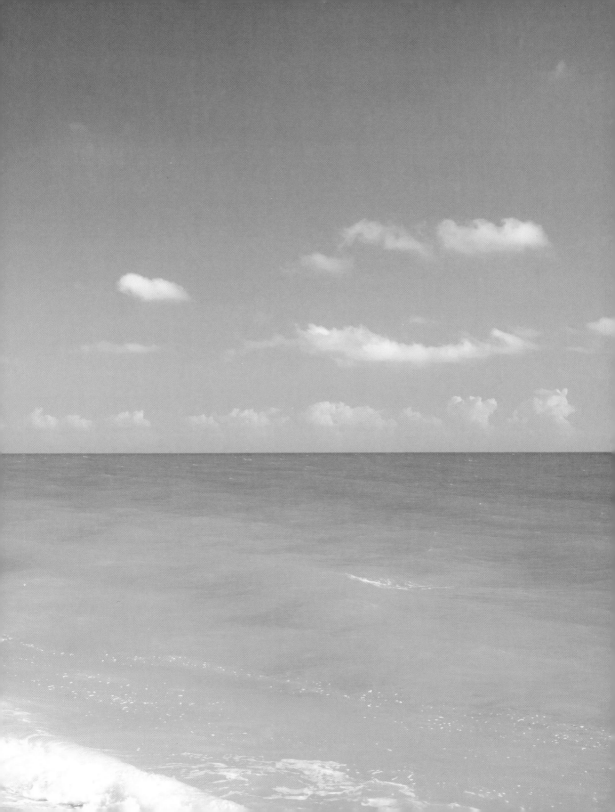

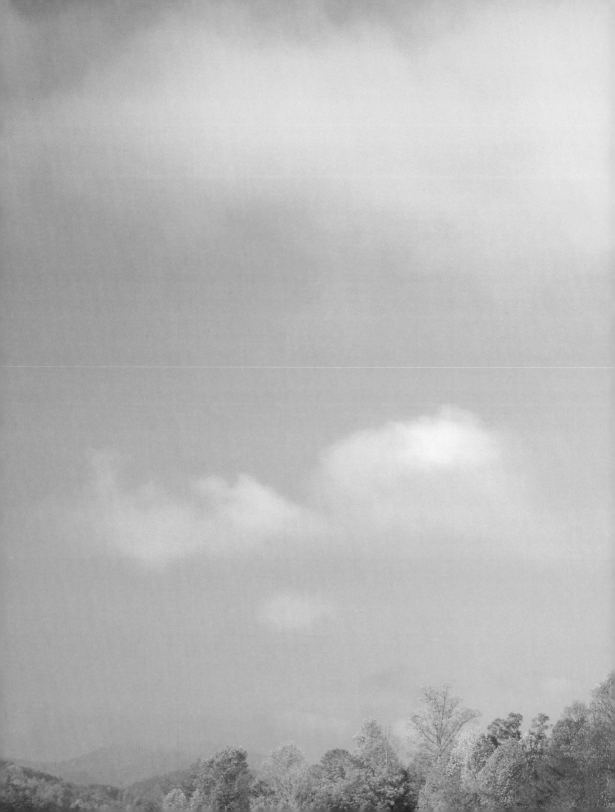

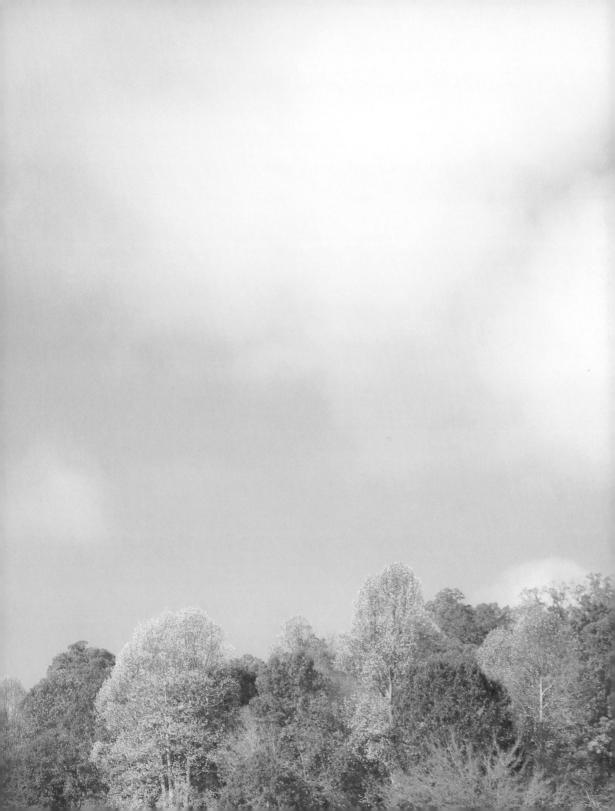

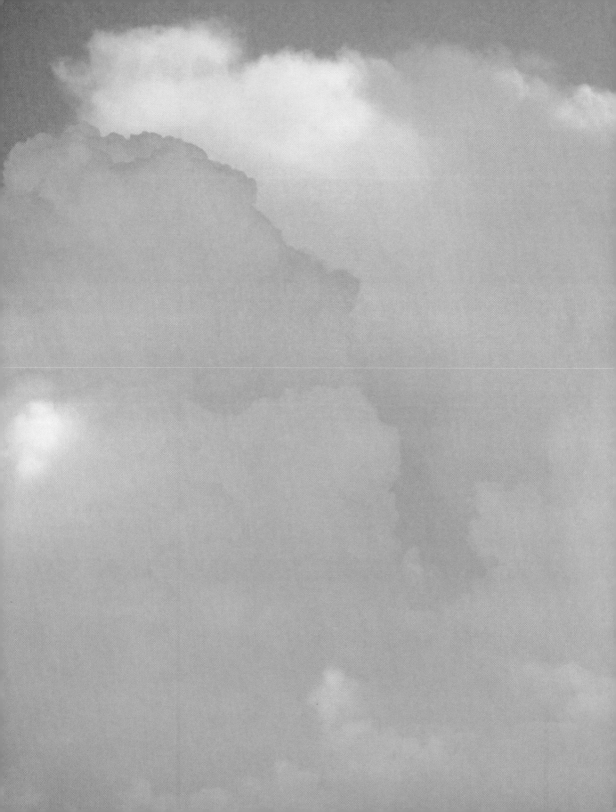

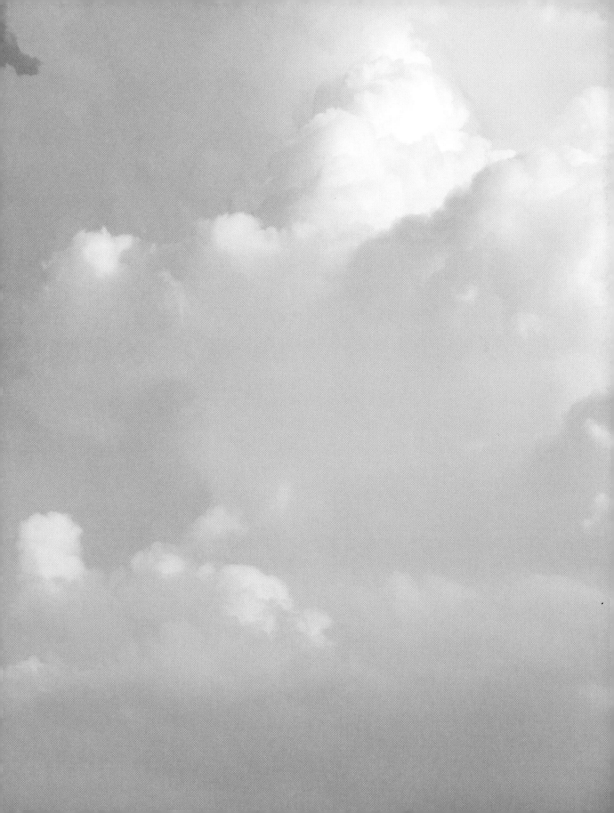

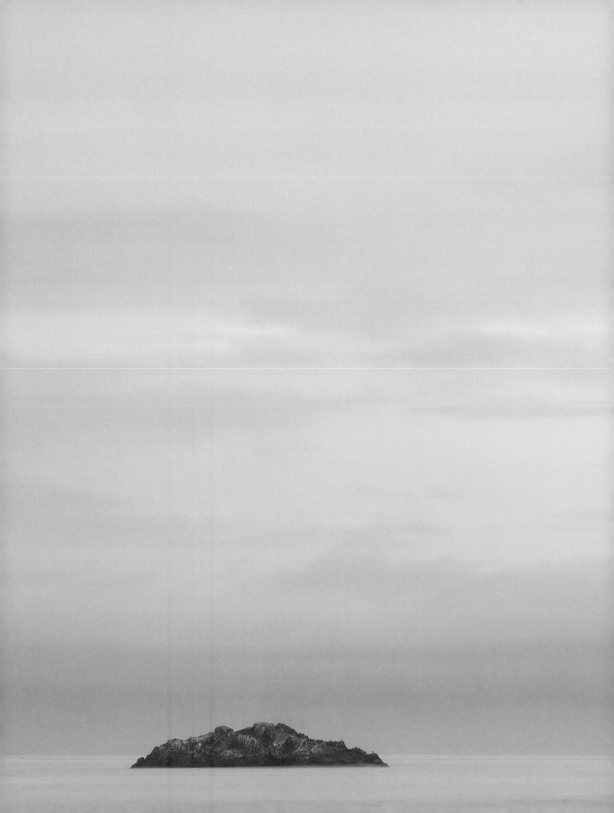

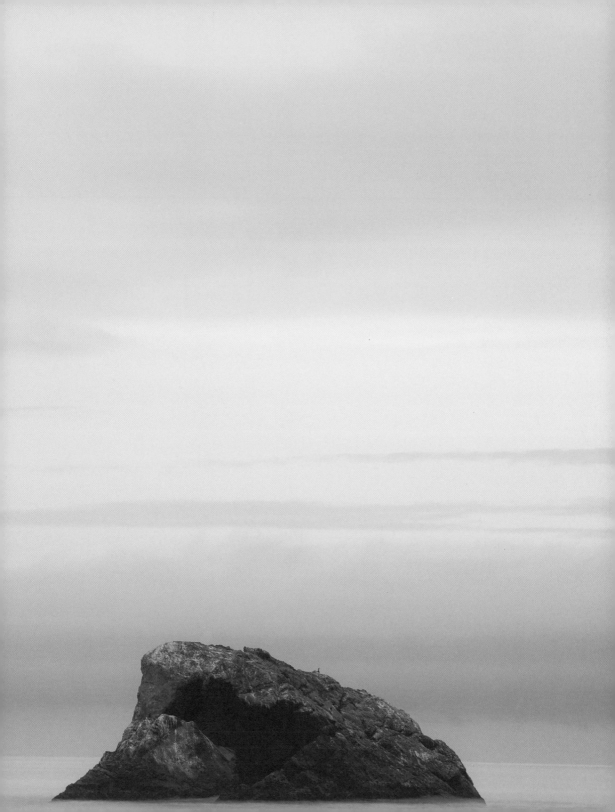

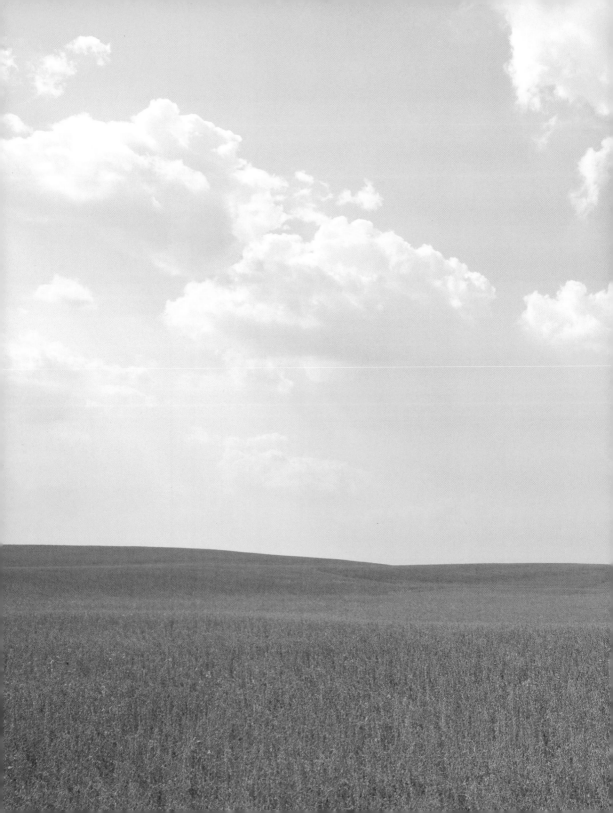

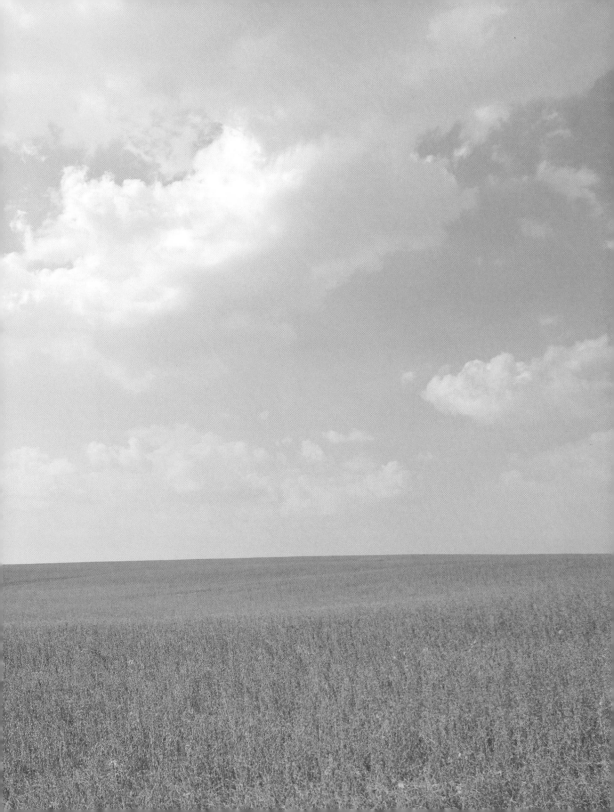

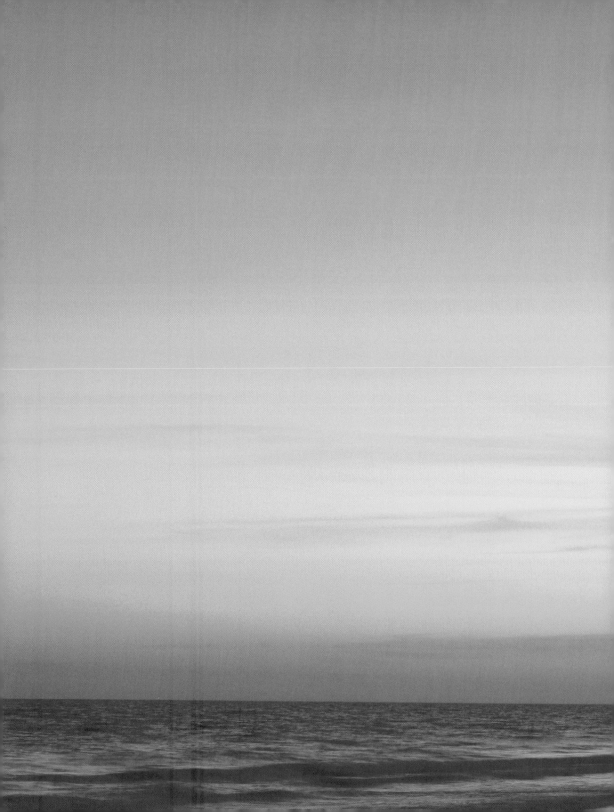

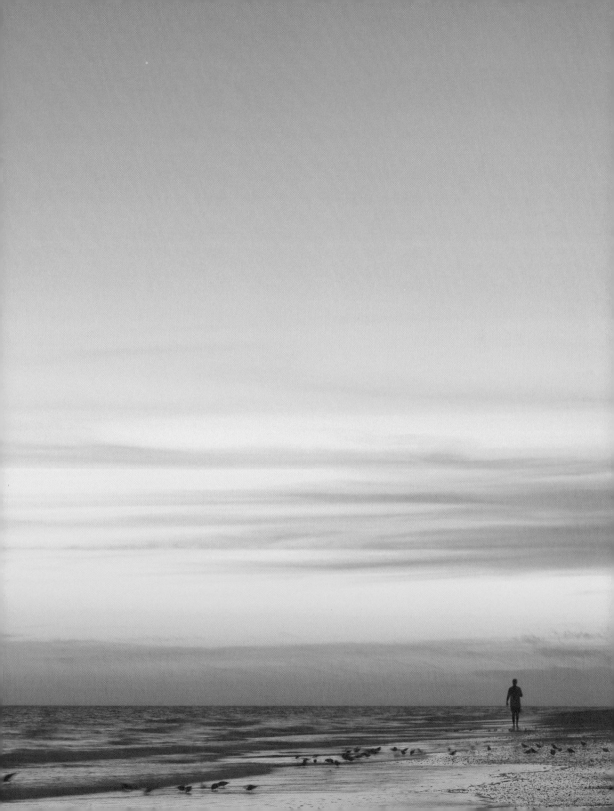

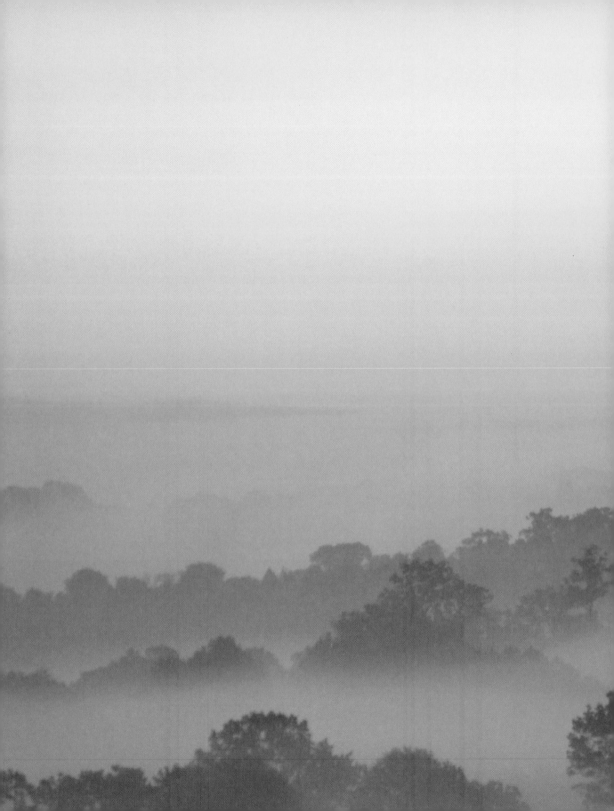

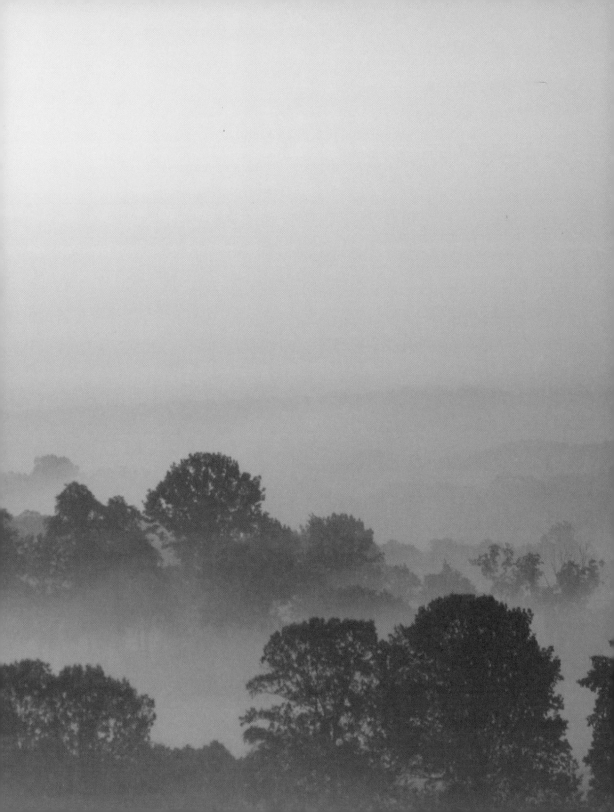

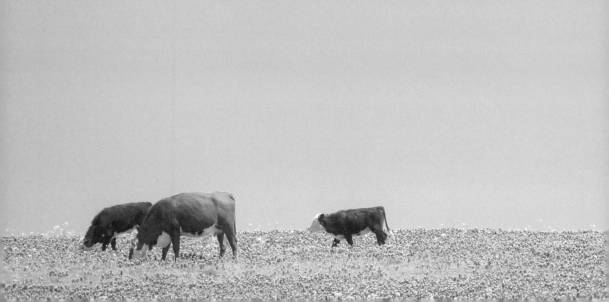

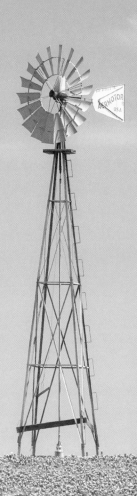

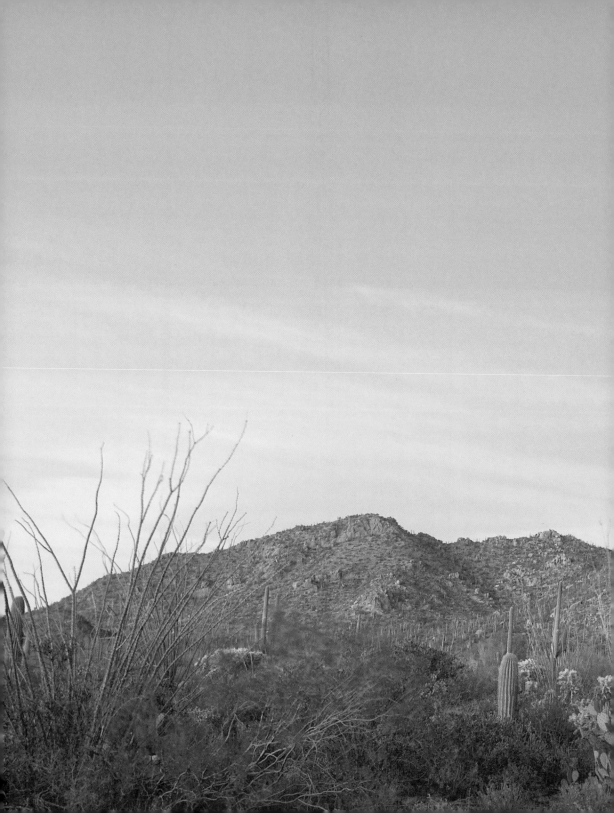

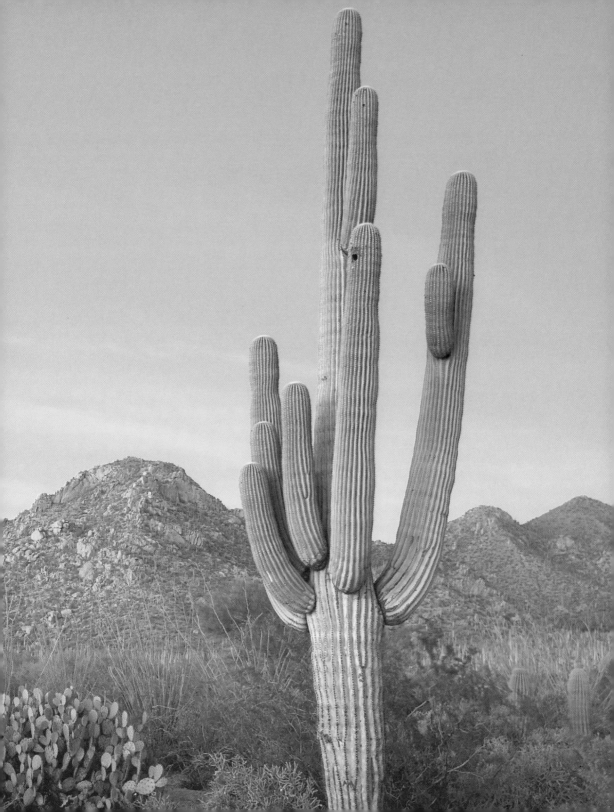

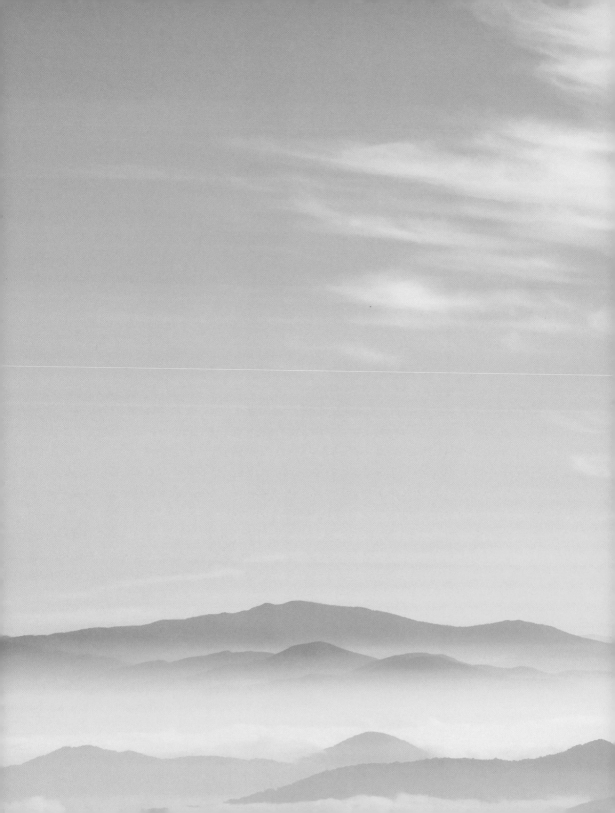

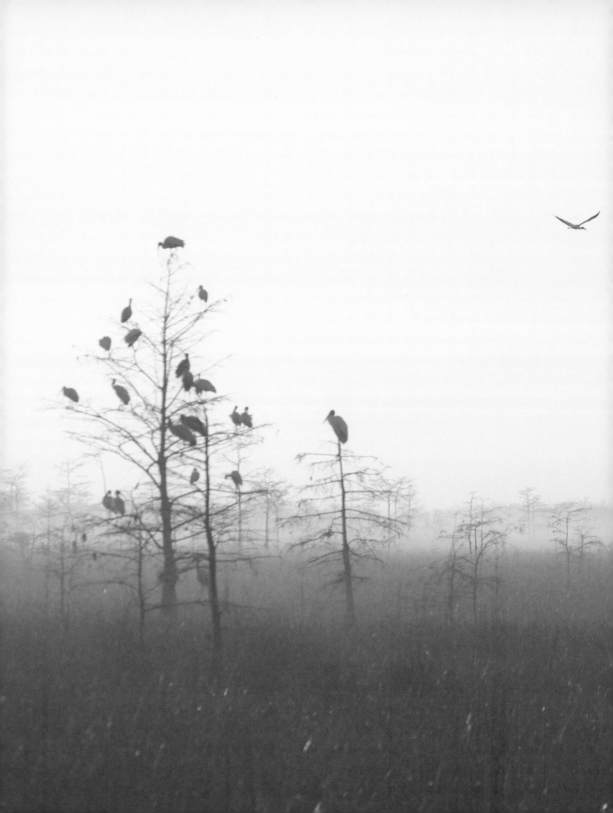

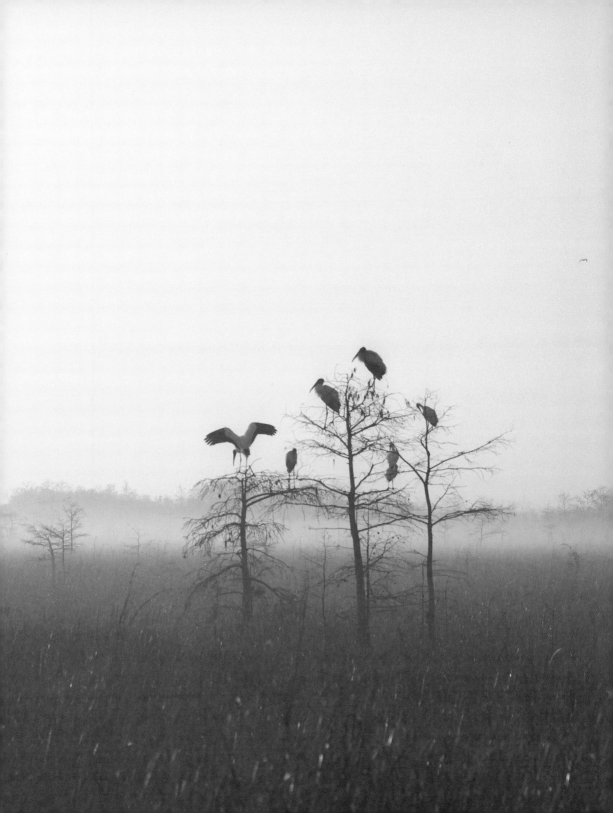

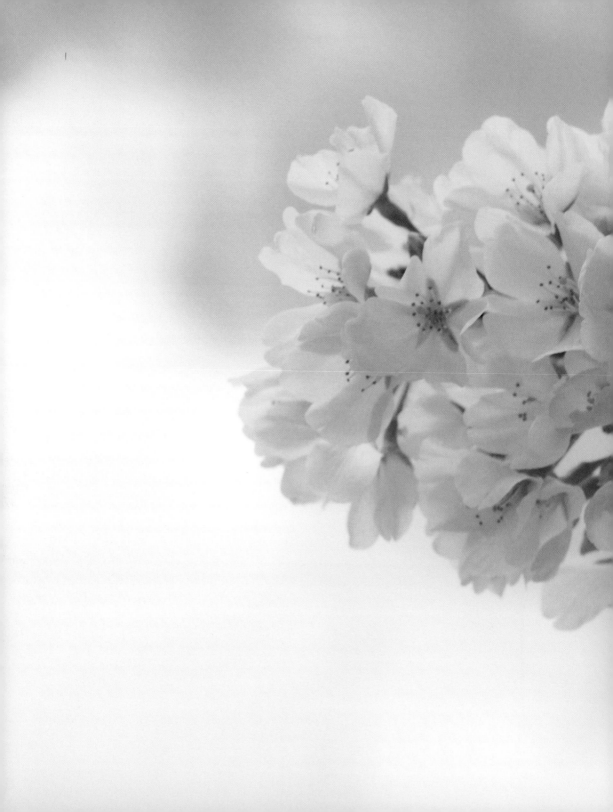

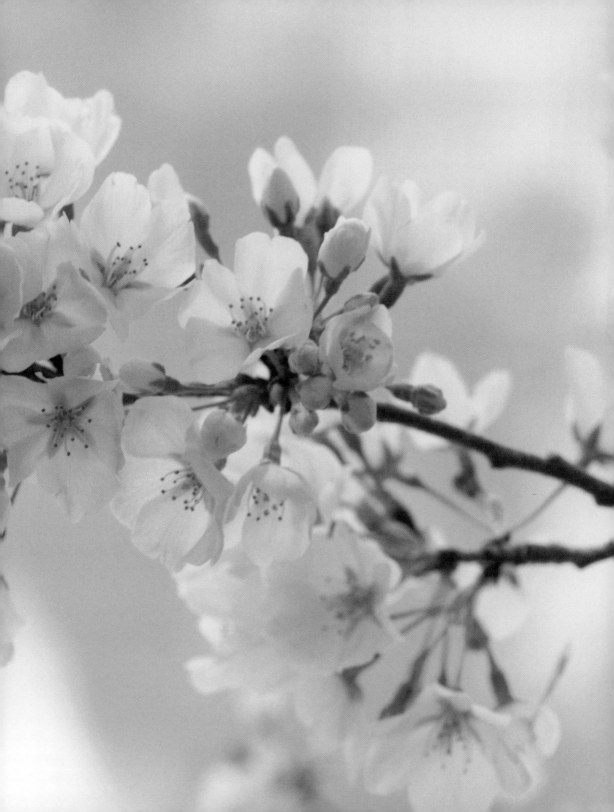

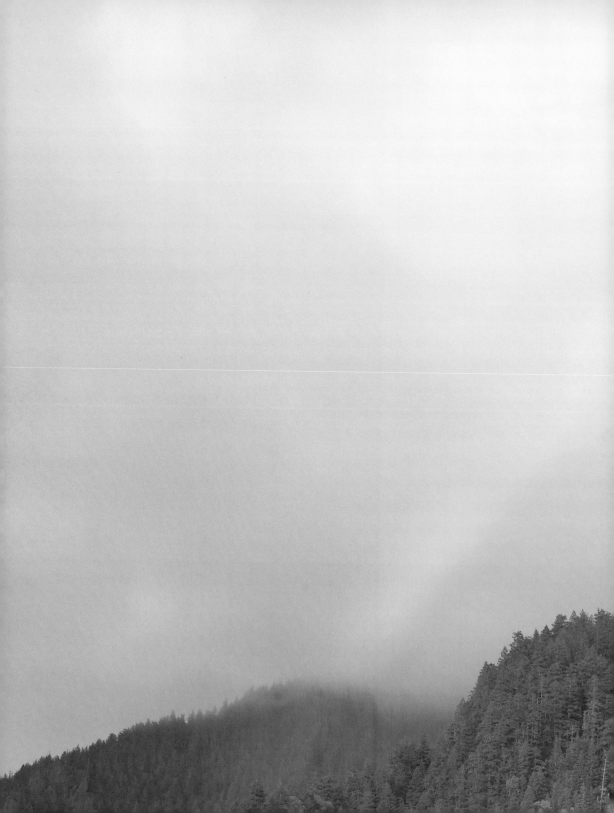

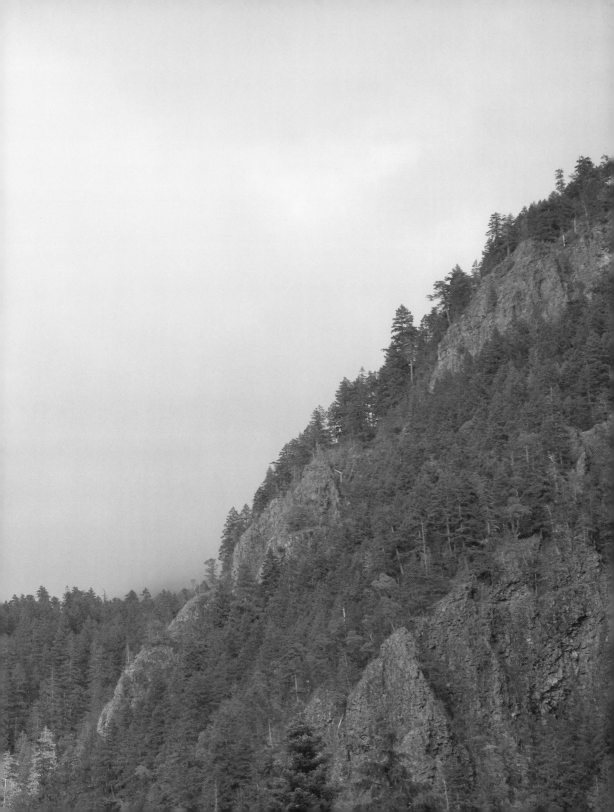

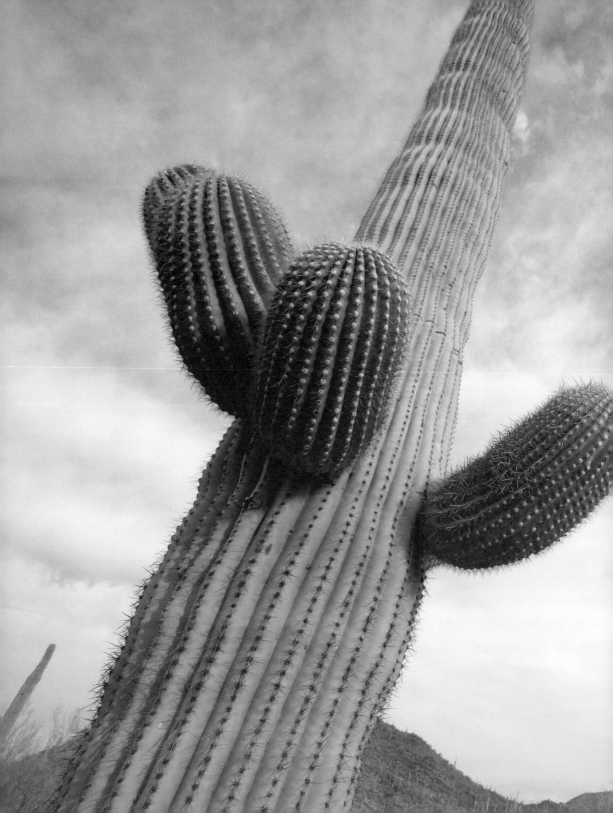

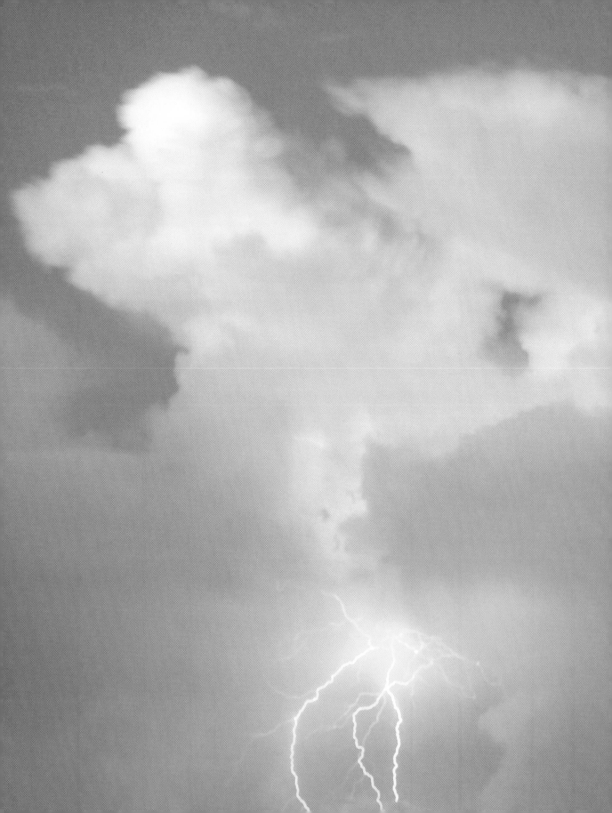

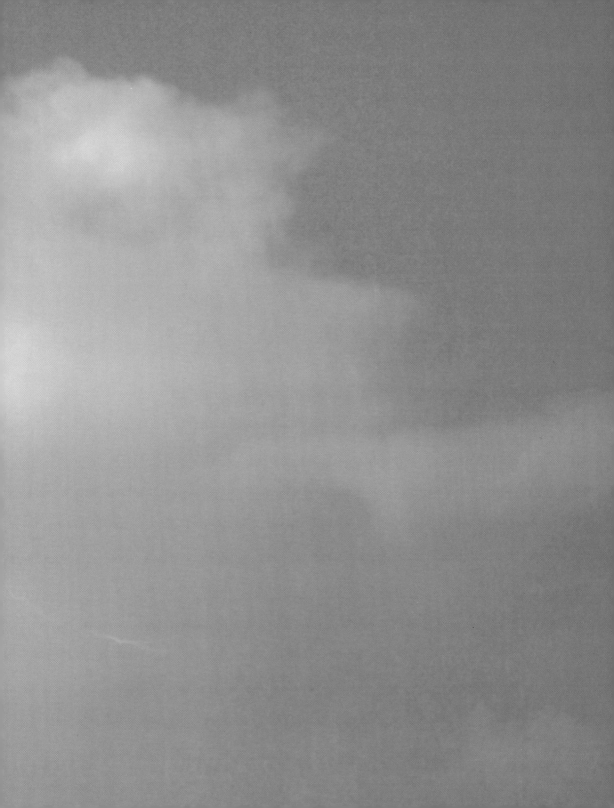

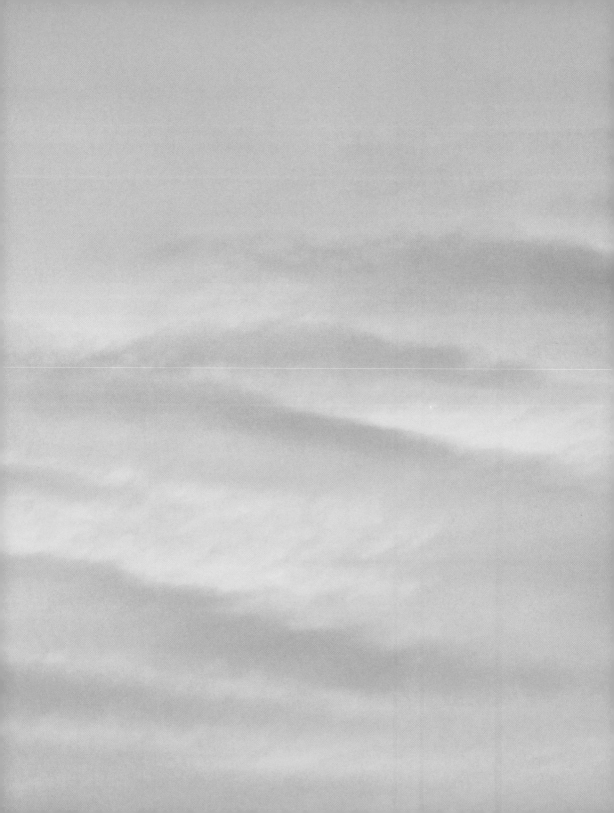

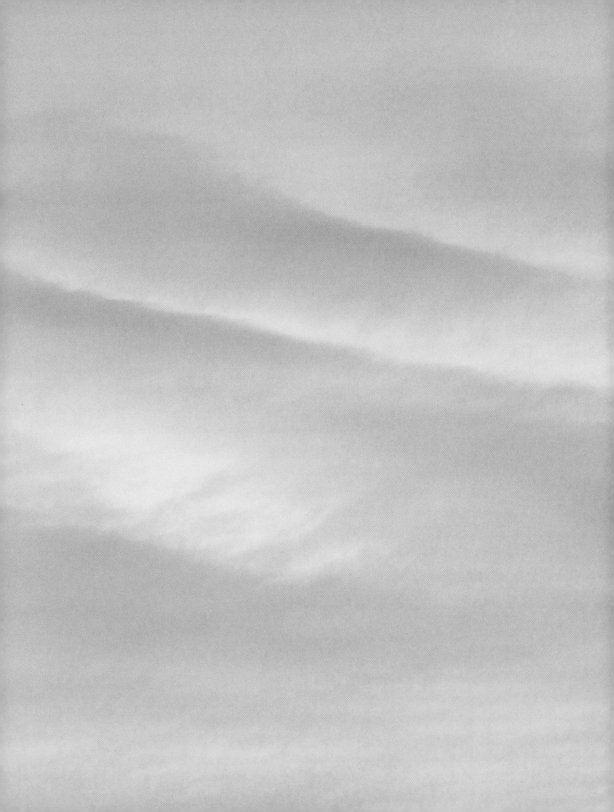

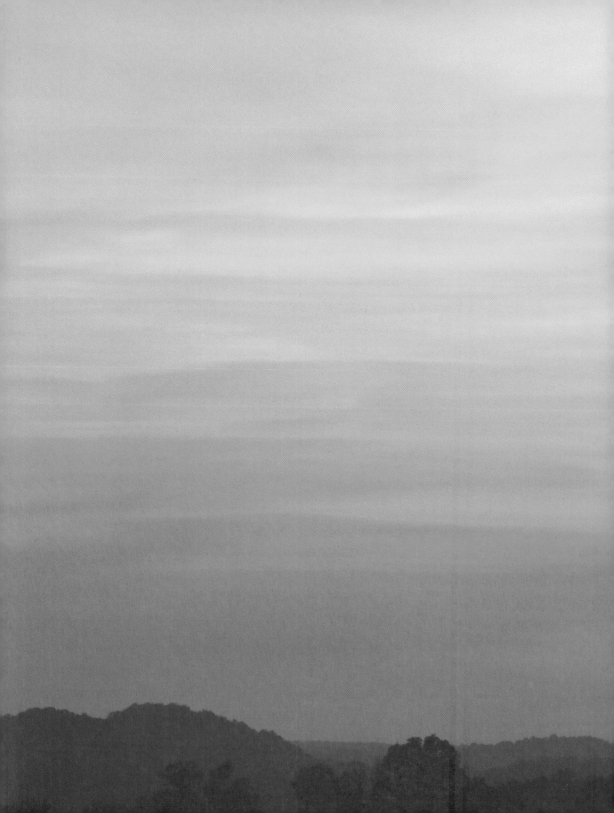

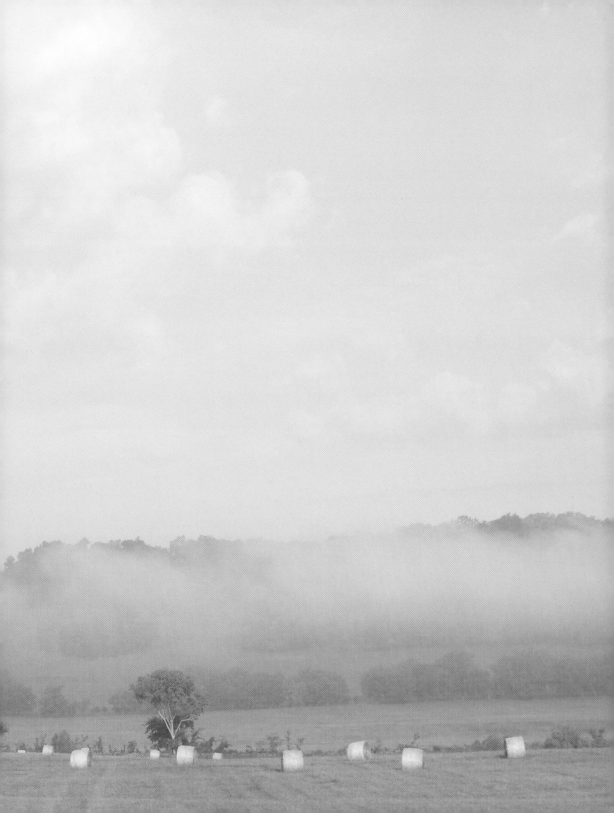

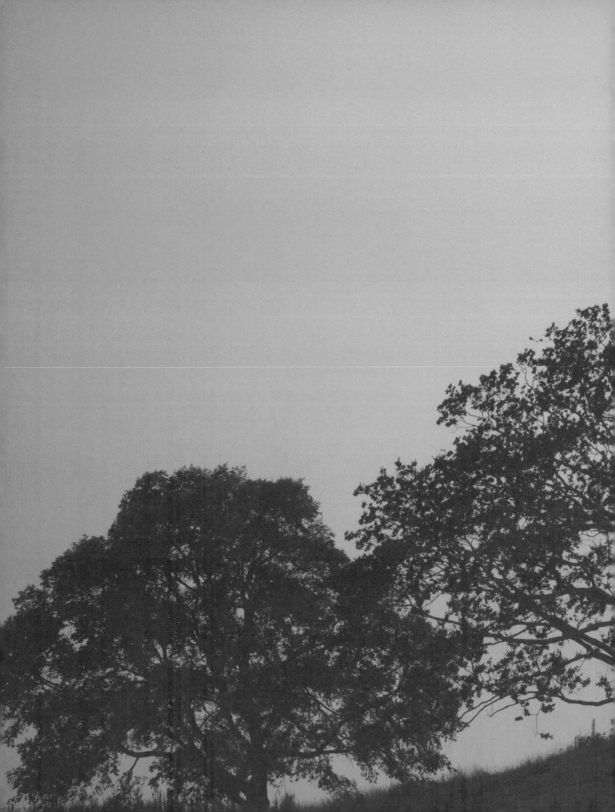

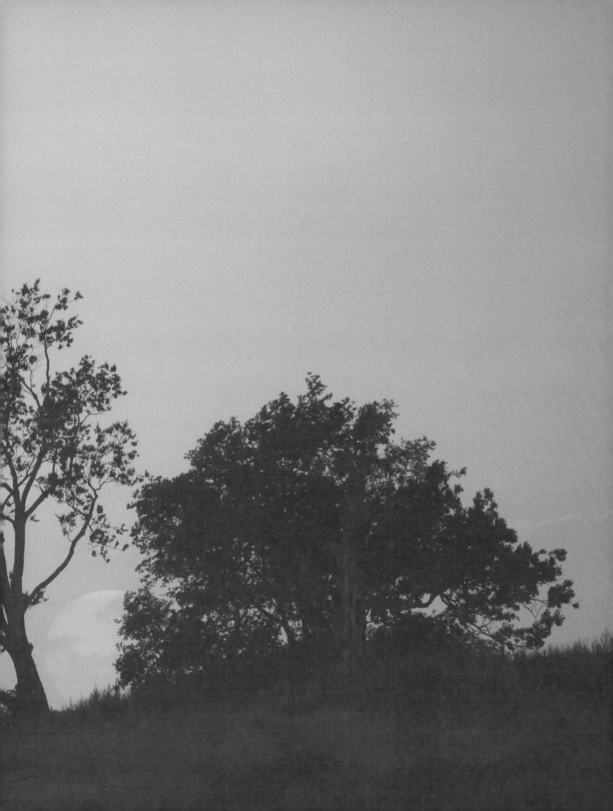

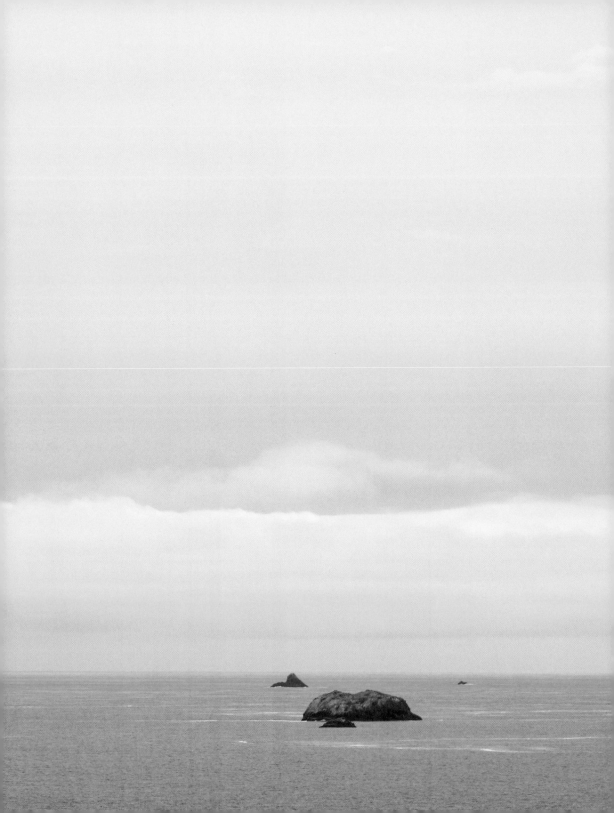

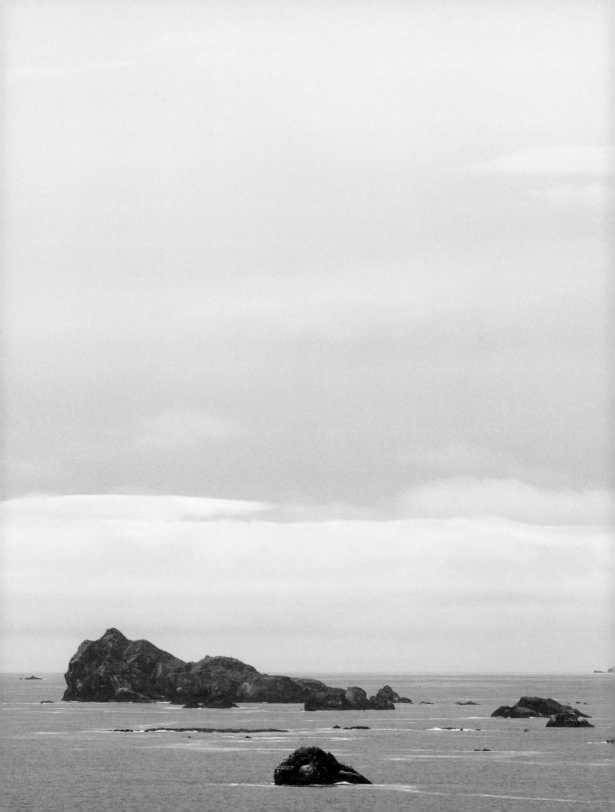

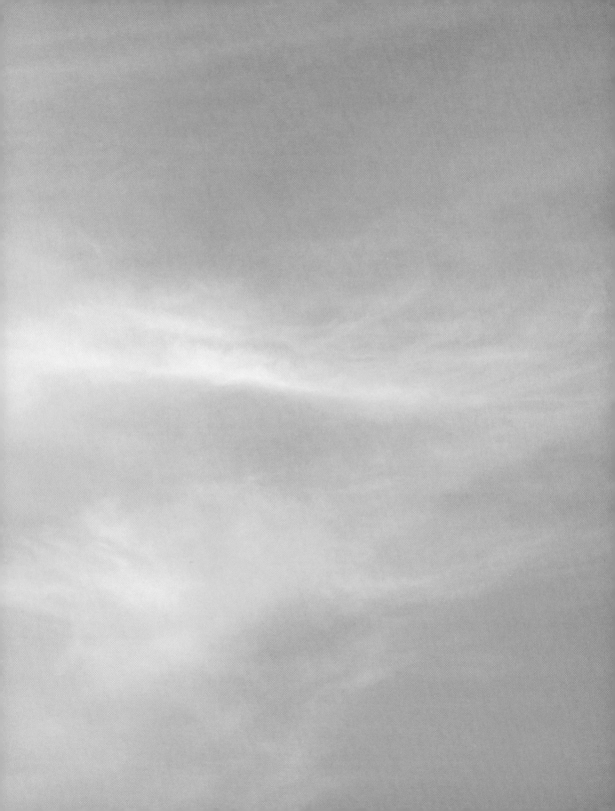

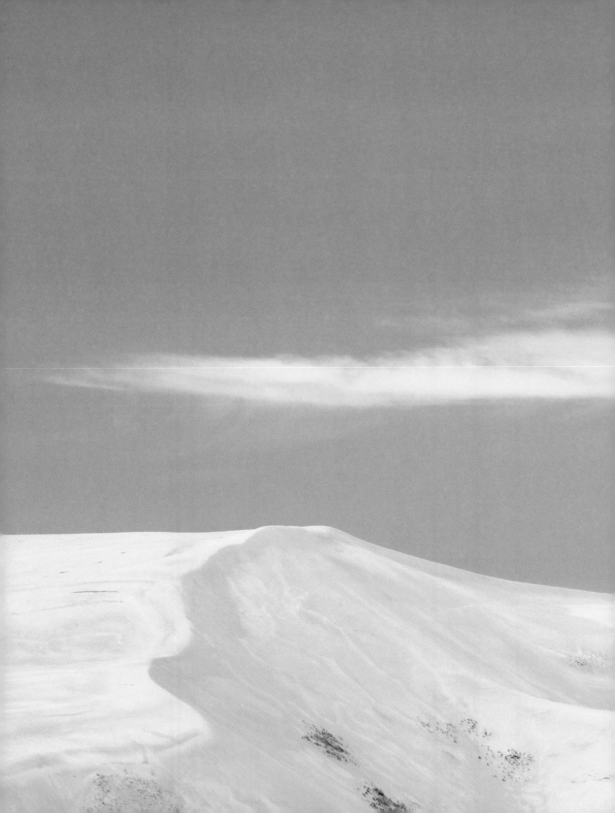

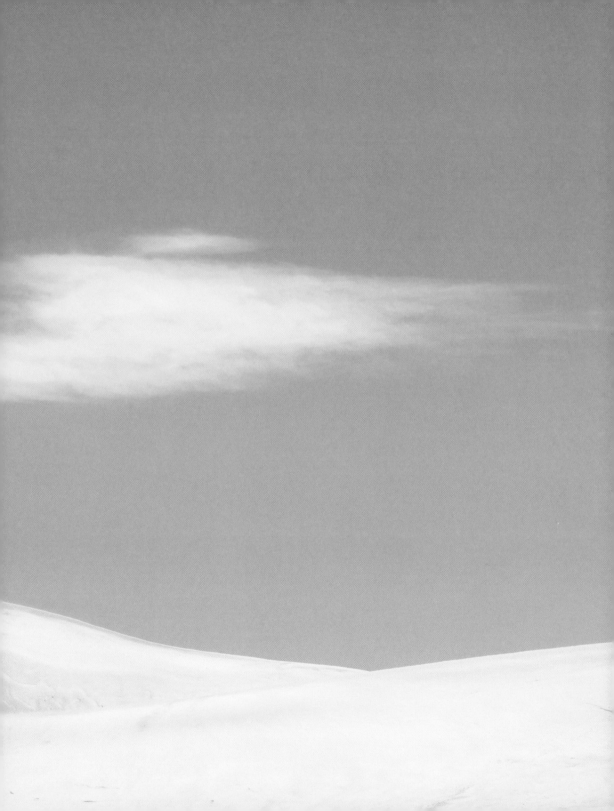

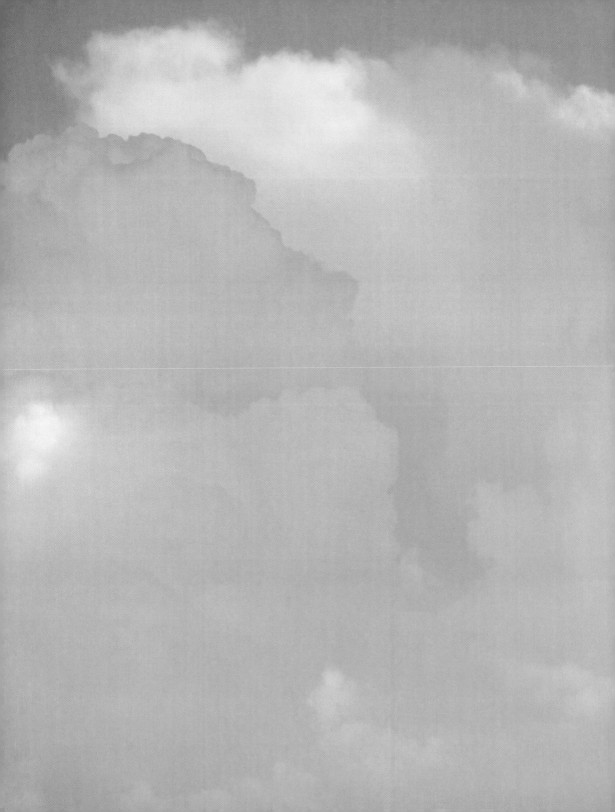

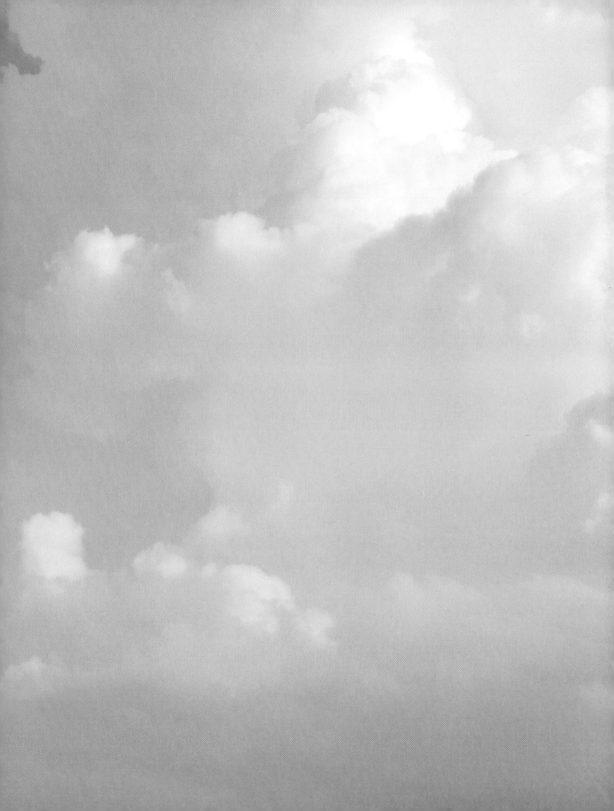

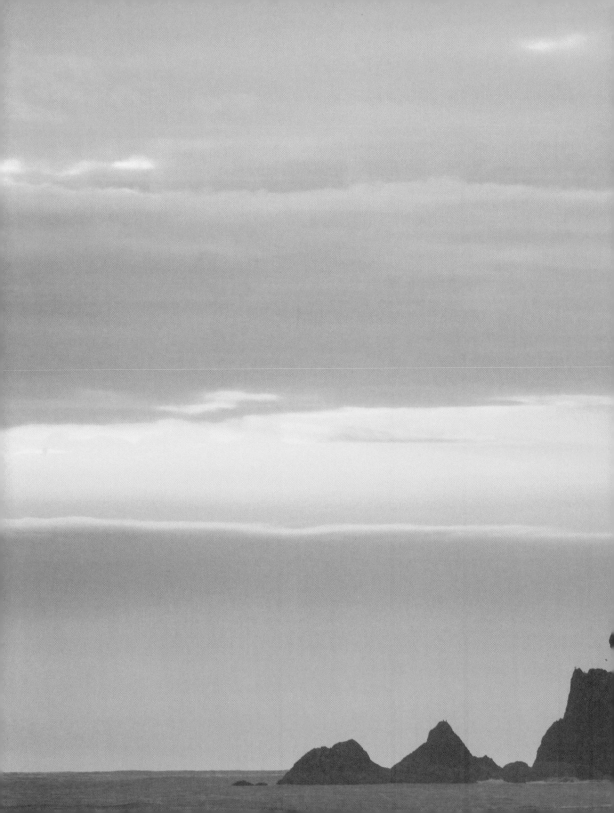

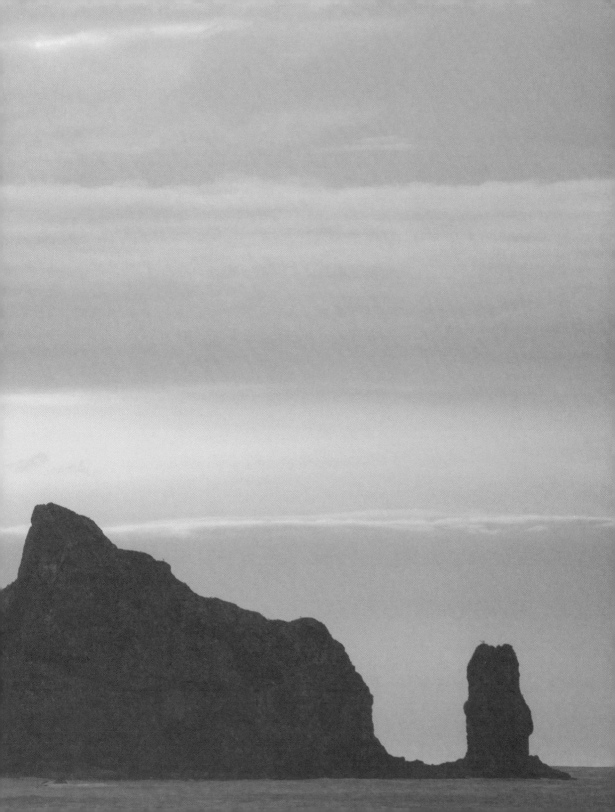

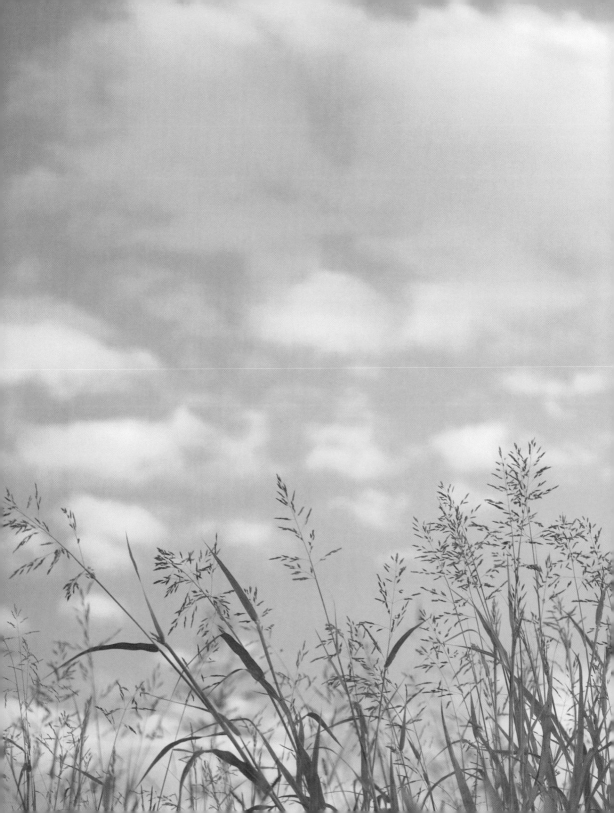

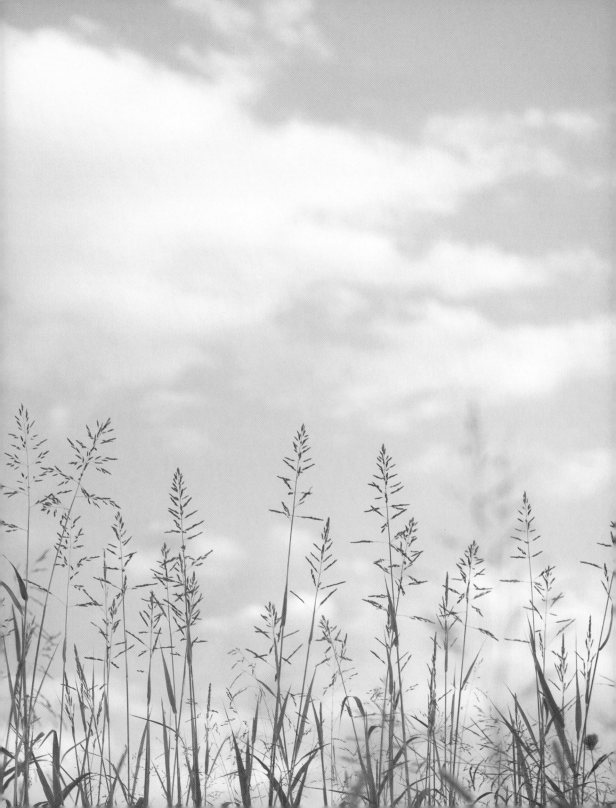

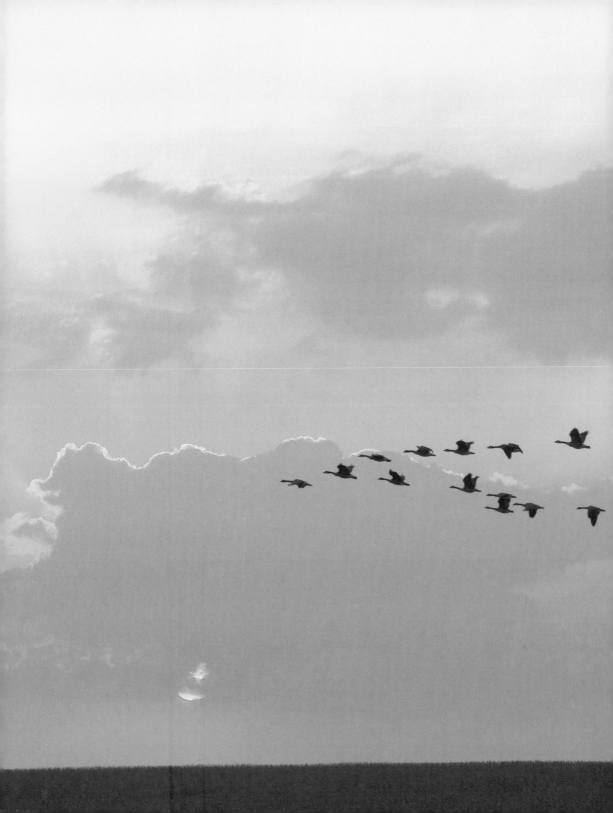

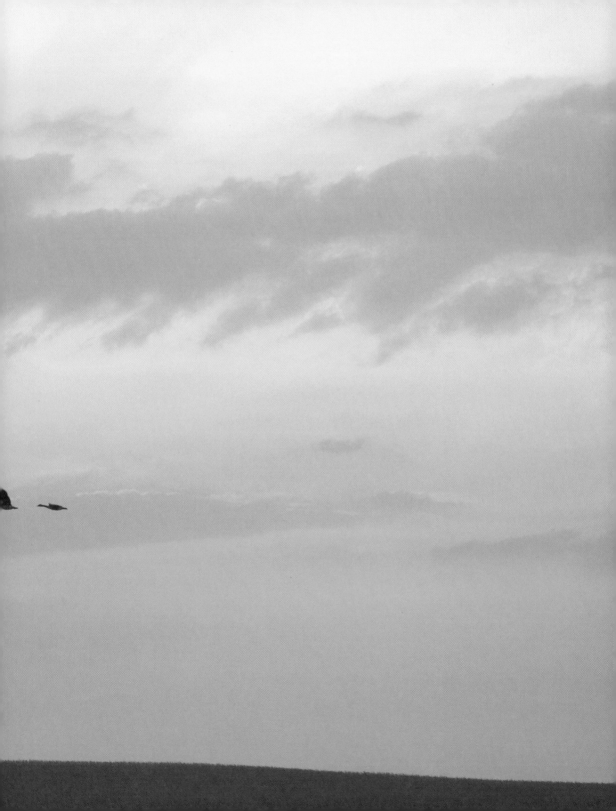

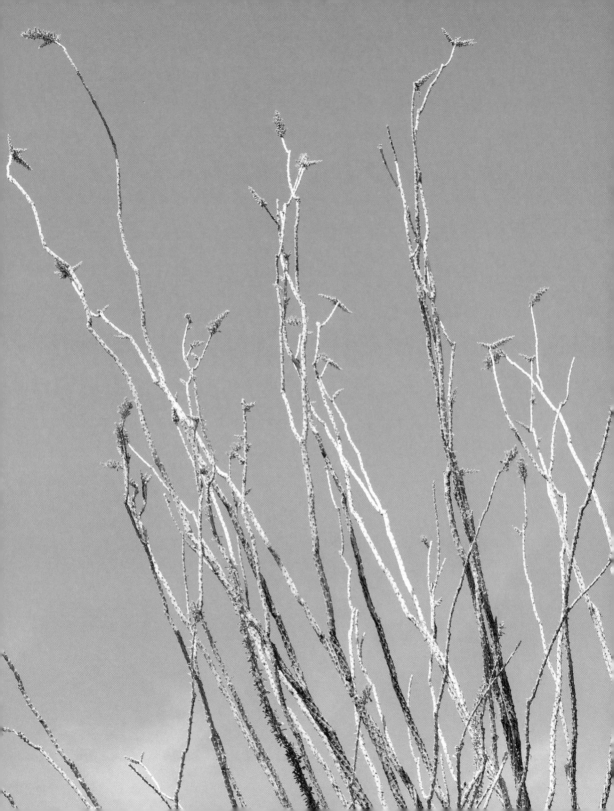

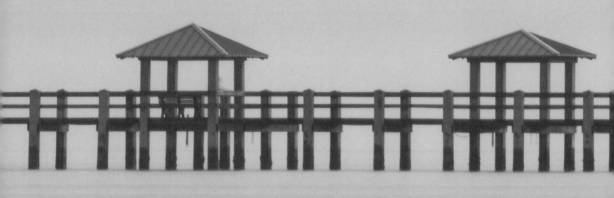

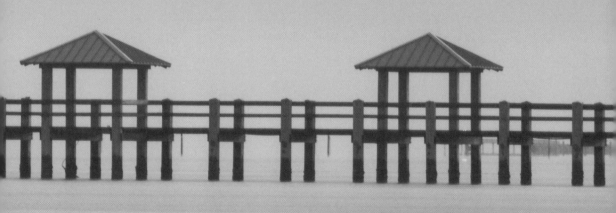

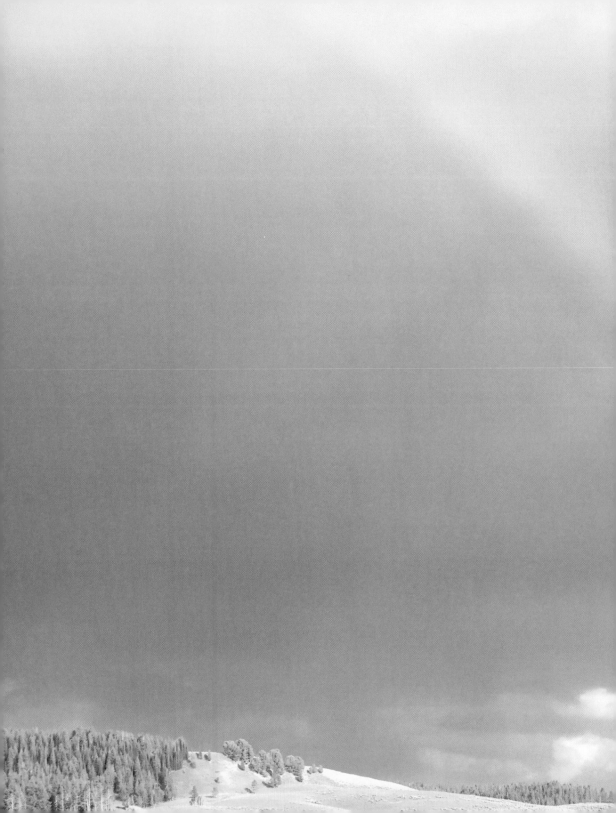

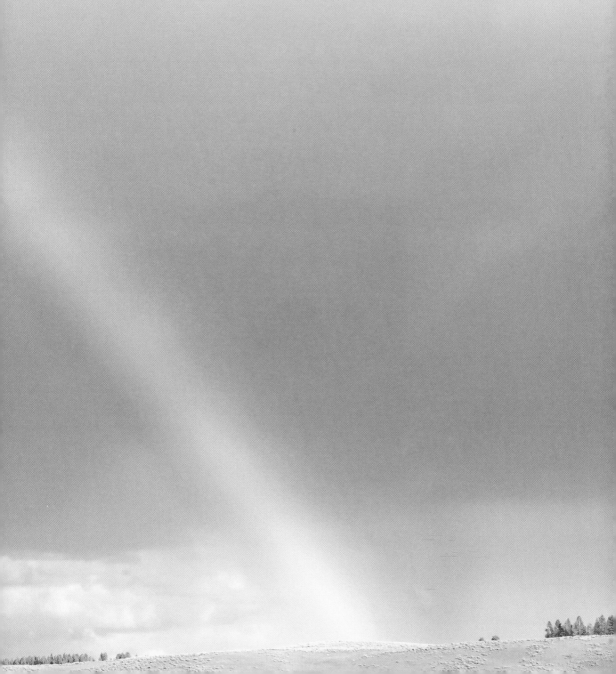

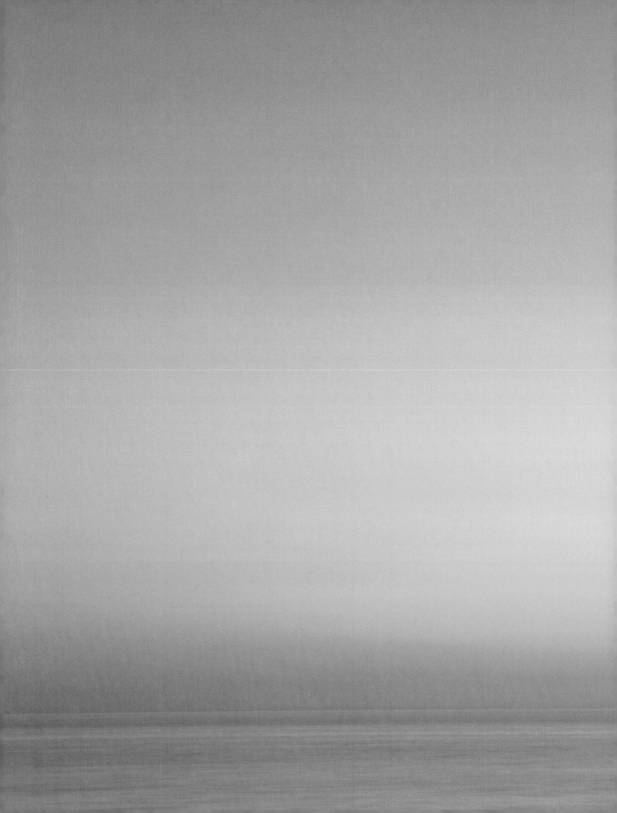

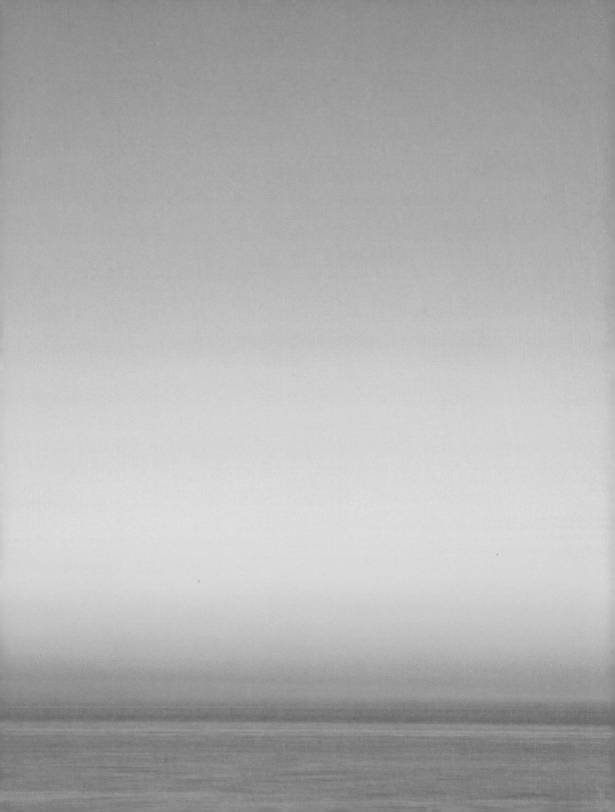

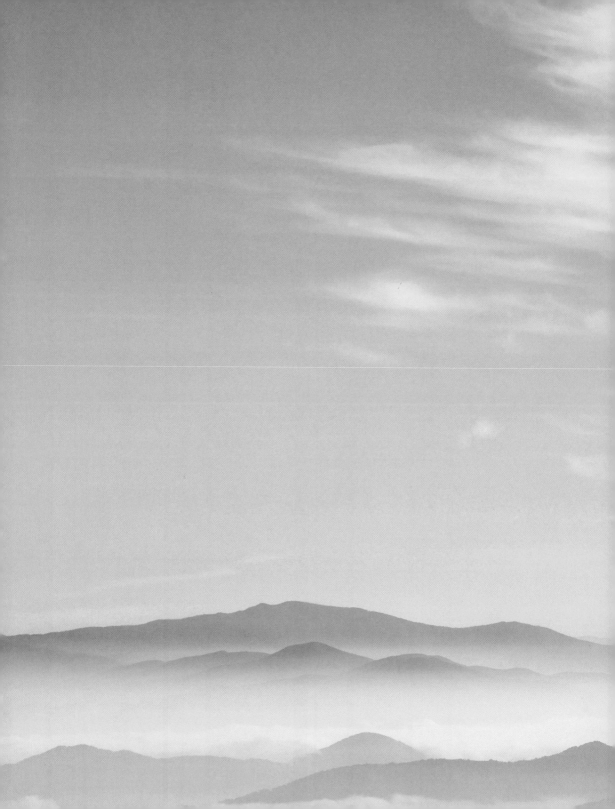

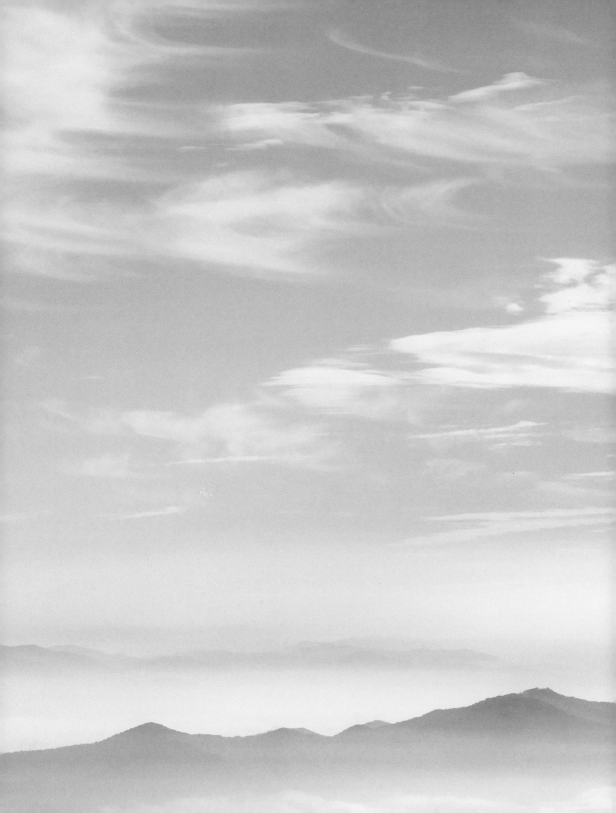

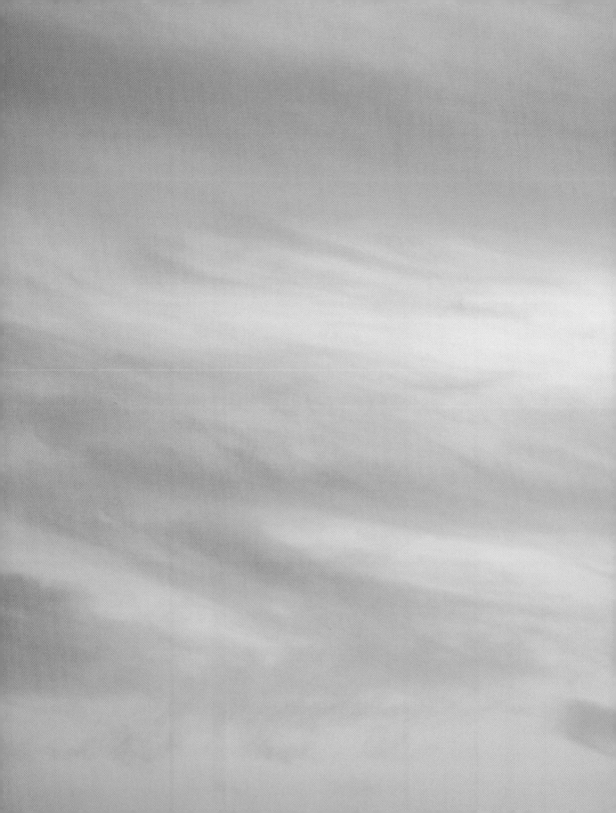

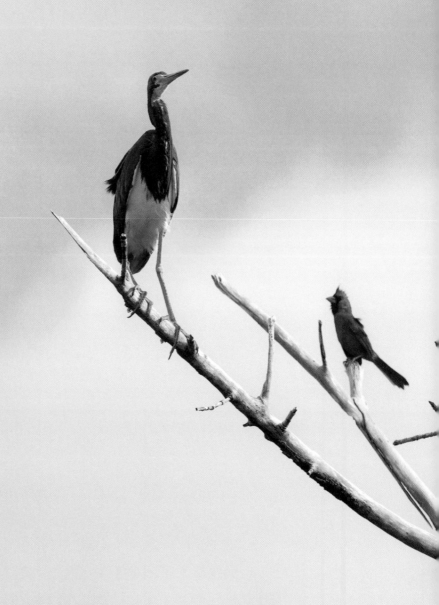

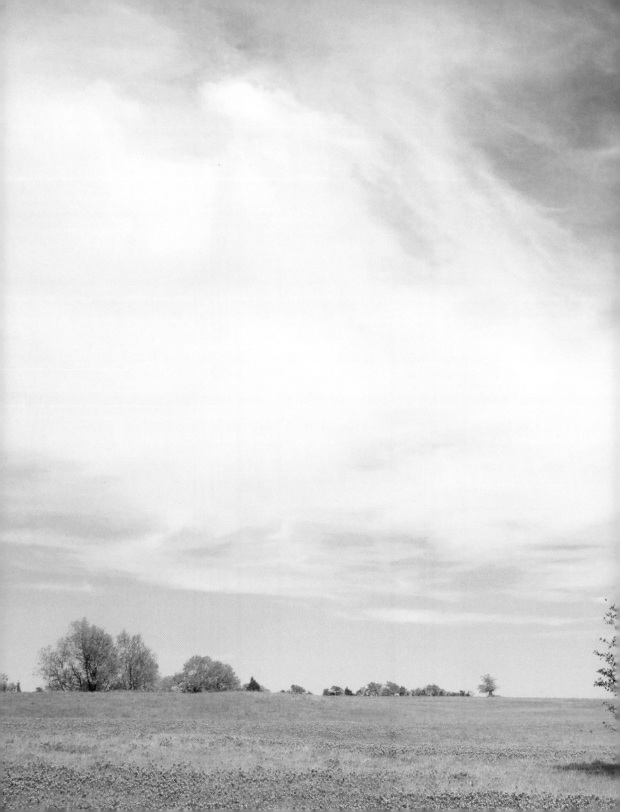

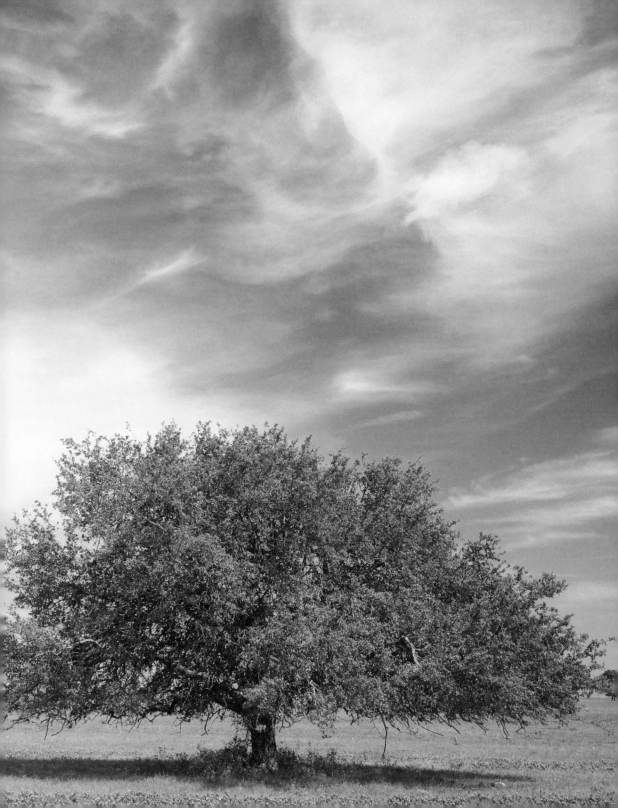

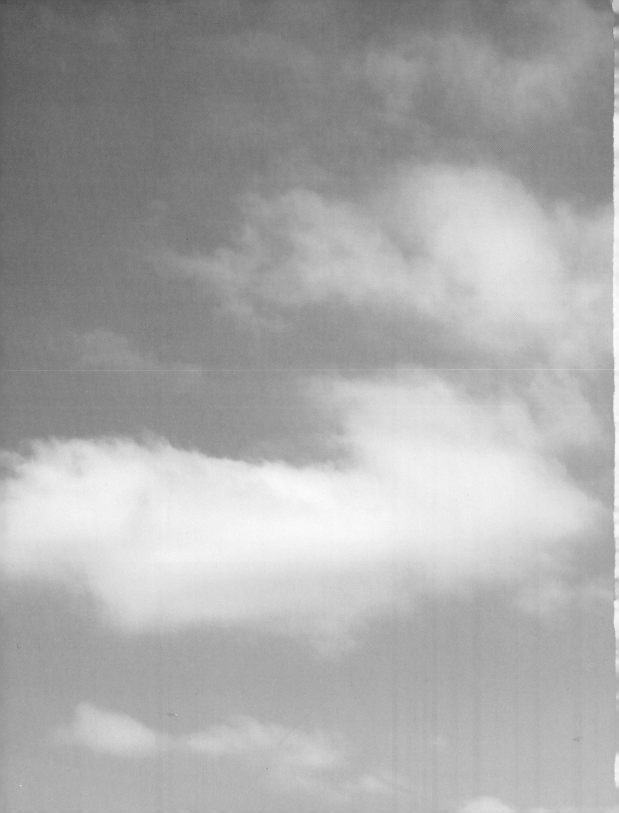